SILENTIUM

Seyfeddin E. Erisen

Copyright © 2014 Seyfeddin Erisen

All rights reserved.

ISBN: 1495494861
ISBN-13: 978-1495494864

HUGE Thanks!!!!!!!! ☺

To make this book be published and giving me good tips for progress of photography : **Heleny CAMPOY** …

To my best friend and brother, **Fırat YİĞİTASLAN**… Inspiring me for photography and standing by me for attempts…

To pre housemates and current housemates for tolerating how untidy I work with my camera inside the house… **Esat DURSUN, Veysel ERCAN, Enver ORAL, Serhat SOYLU, Murat KAYA, Ferhat KAYA** …

To **Recep MERCAN,** for standing for poses and helping me always …

To **Serhat YİĞİTASLAN,** helping for gadgets in the house and organizing photo fields and shoots…

To my beautiful piggy sweet faced, **Mia Milena BALABAN,** for organizing models….

To another Serbian Chick, my sweet friend **Andjela SLADIC,** for very difficult arrangements.

To my first model, **Fatih GÜLTEKİN**…

To my beautiful *chica,* **Rocio Coral TRINIDAD,** for helping me…

To My precious, beautiful and talented friend, **Öykü KARADAĞ** …

To **Ana Ćulafić** for bringing **Leo**…

To my awesome and hot 'spanky' models **Gabriela MERELE, Merve UCAR , Zaga DRAZILOVIC, Nevena STEFANOVIC, Srna Bambi SILJANOVSKI , 'Johnson HARDGROOVE'** (Nidža Jabuka)

To my brother **Hüseyin SALIKOGLU,** for standing there always and advising me…

To my friend **Tansu DEMIR,** for supporting and provoking me all the time…

And to my one of my best friends, for backing me up **Angela**….

Seyfeddin E. Erişen

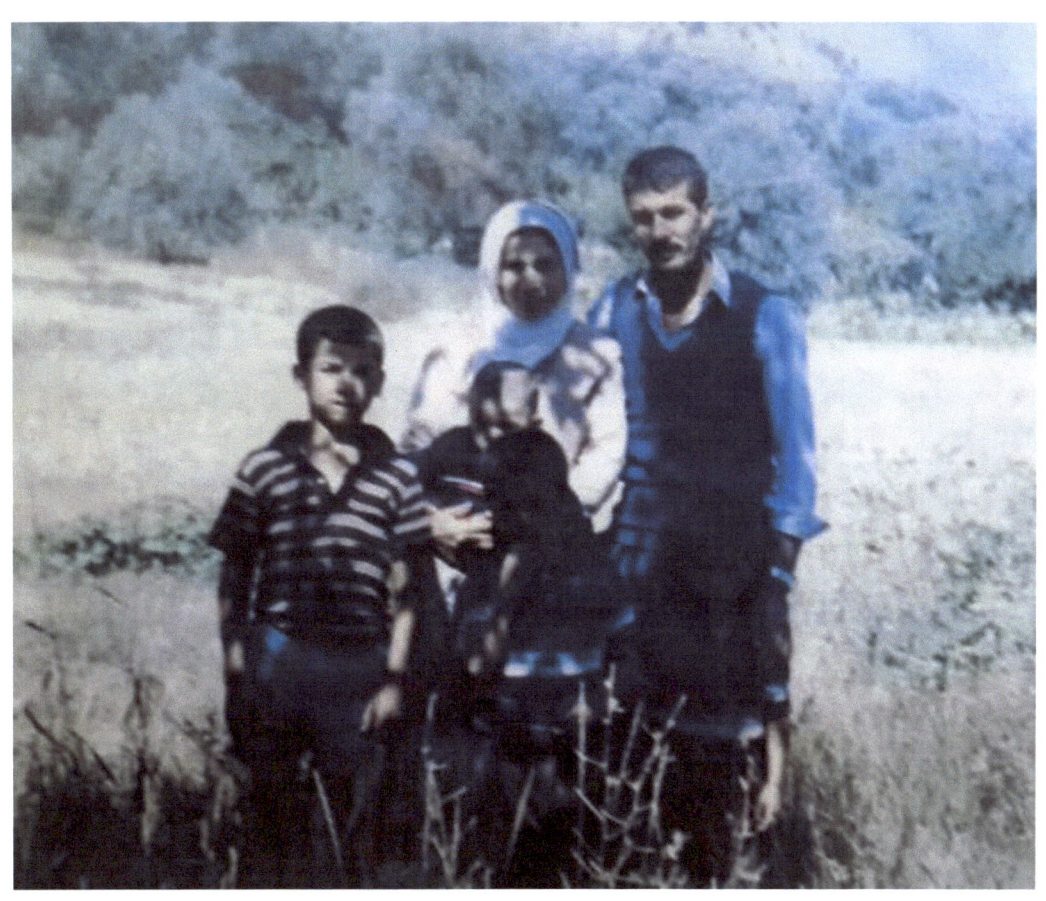

… to my family…

Silentium is the bridge on which humans are happy and unbiased...

She never proselytizes,

She never judges, never questions but, she observes...

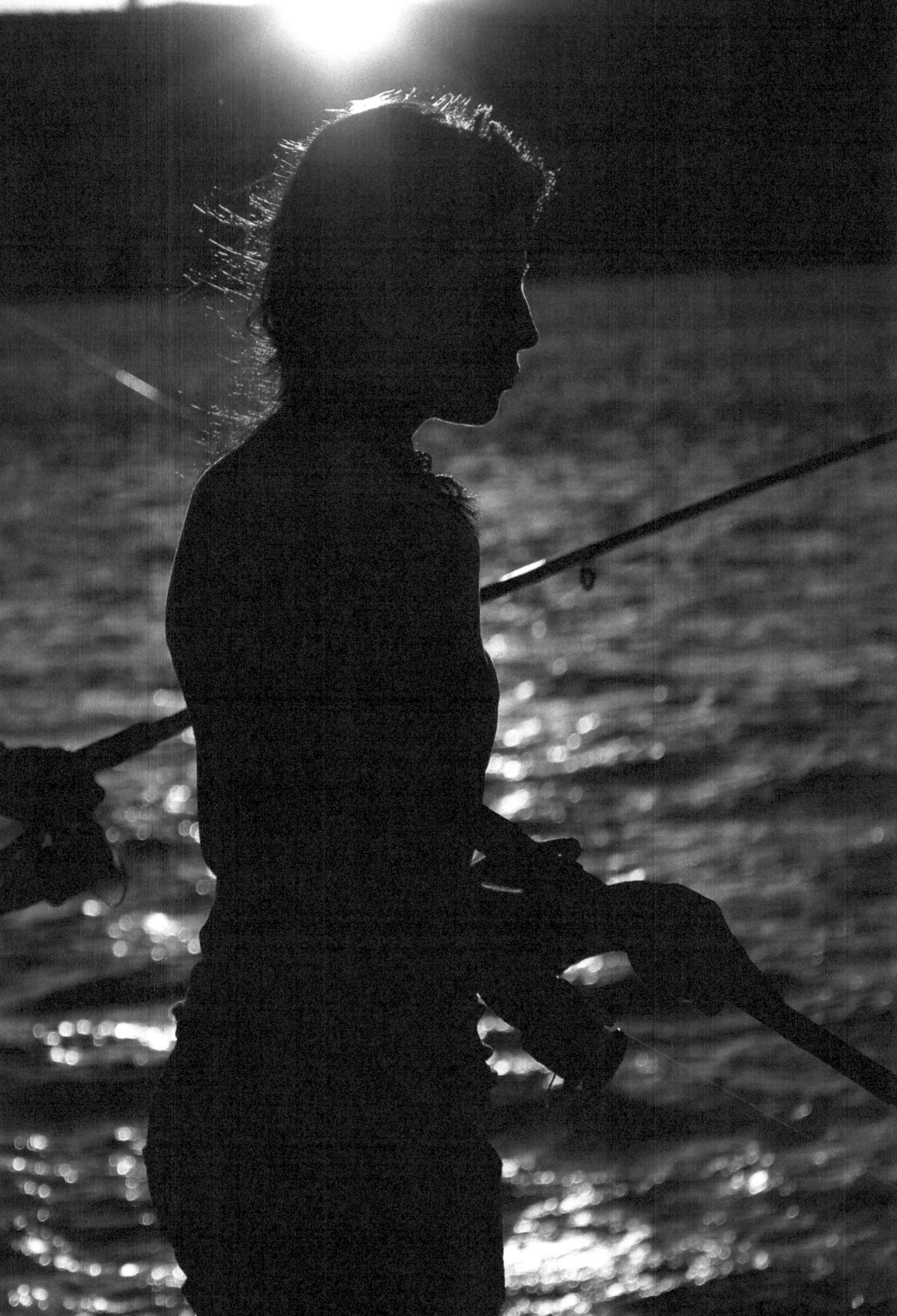

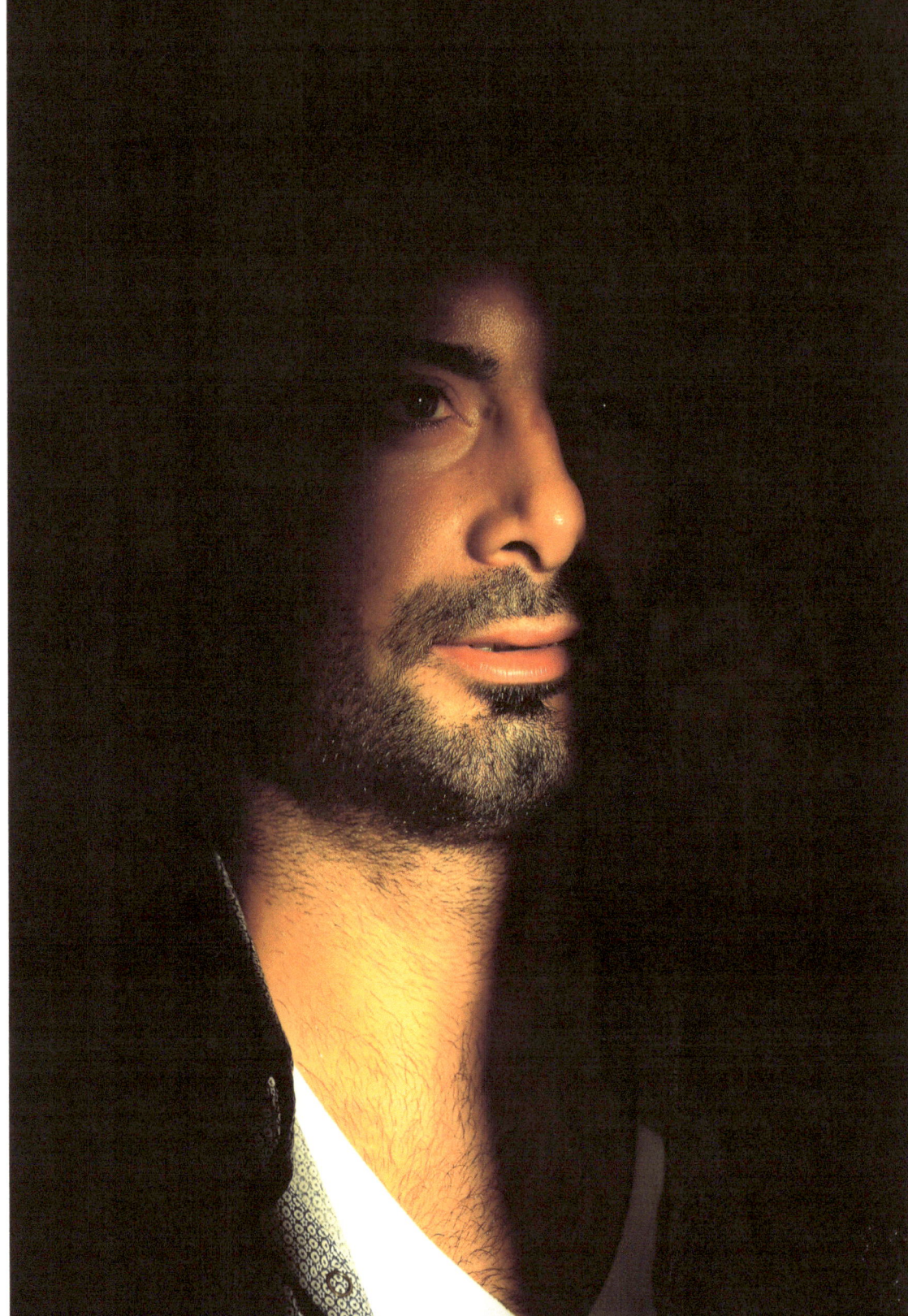

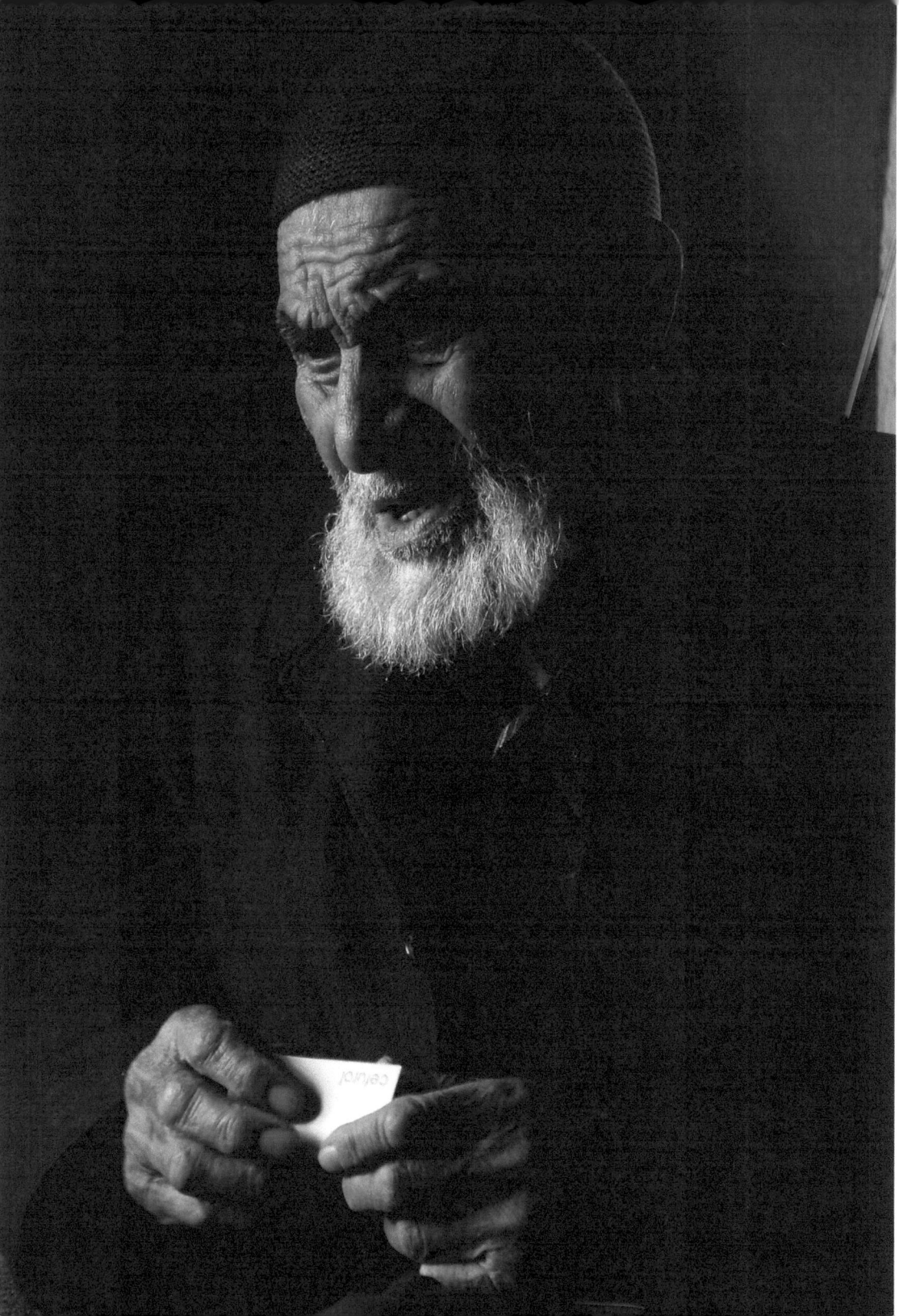

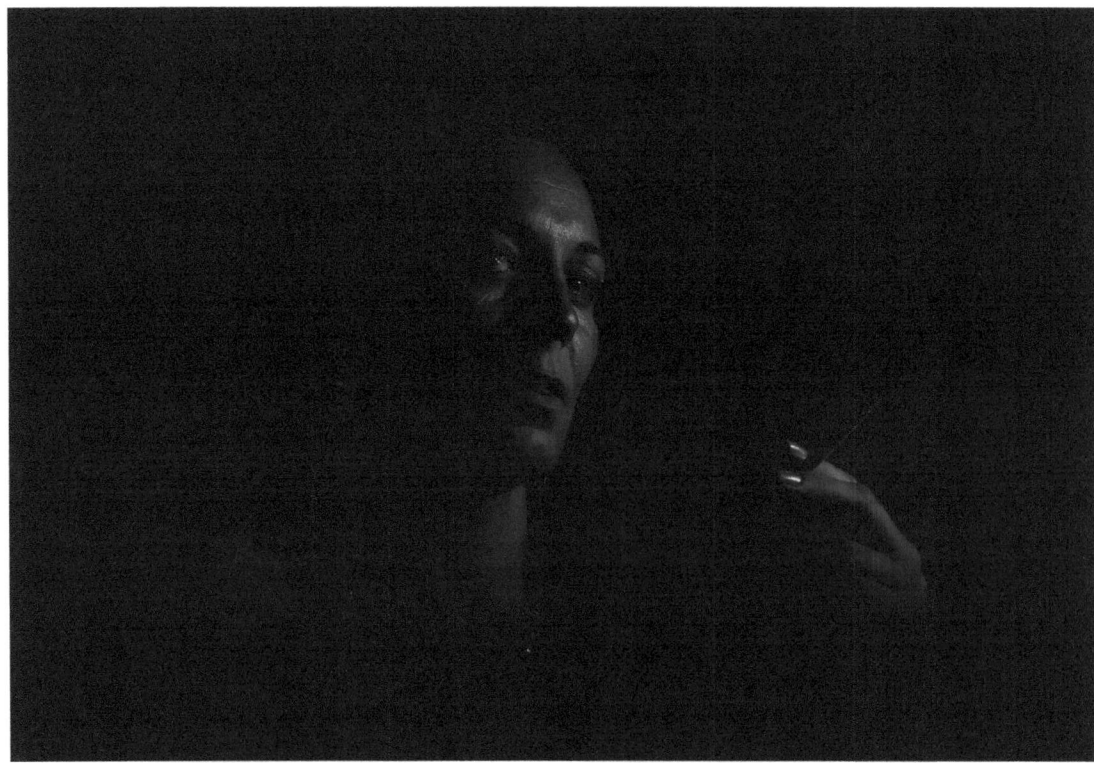

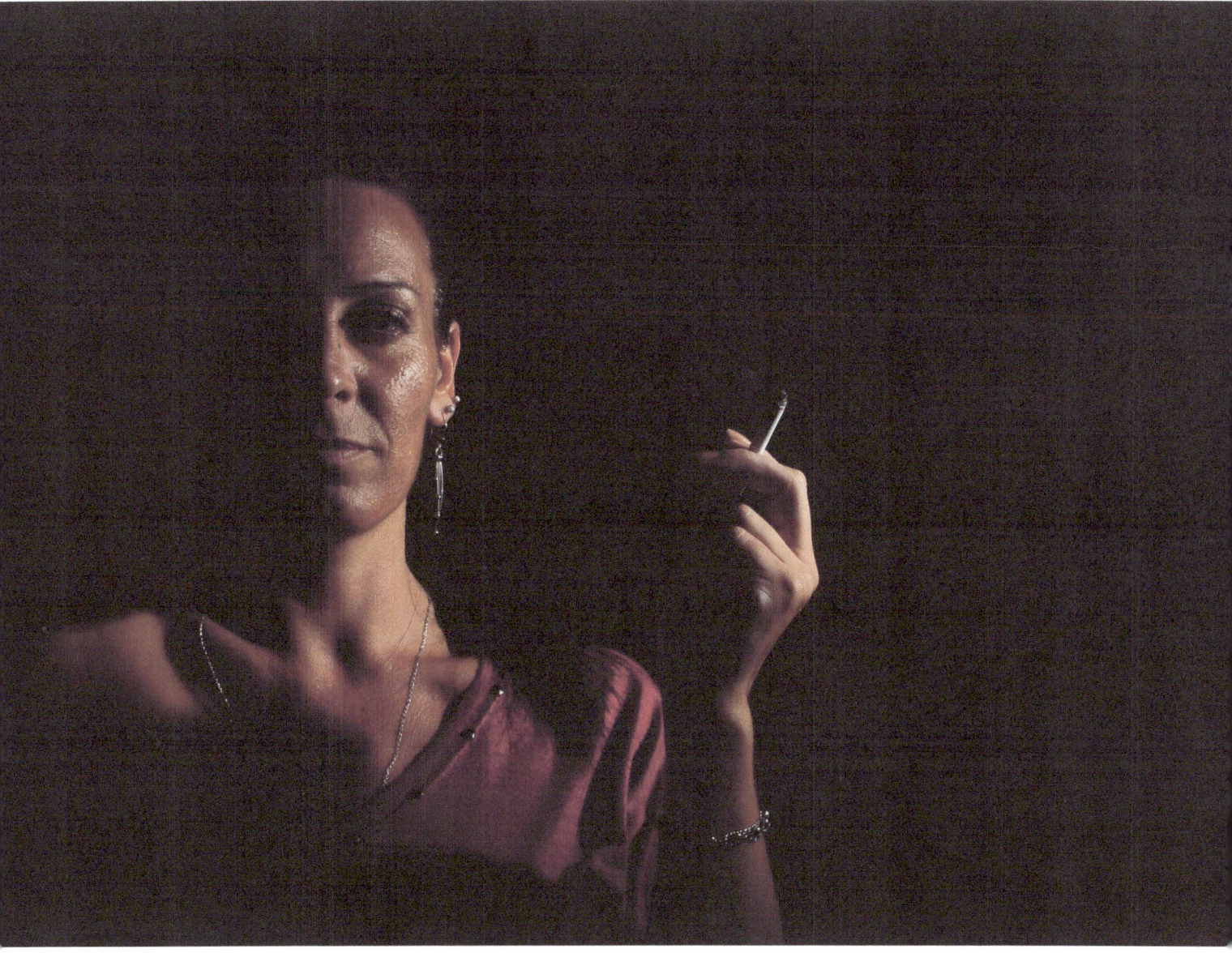

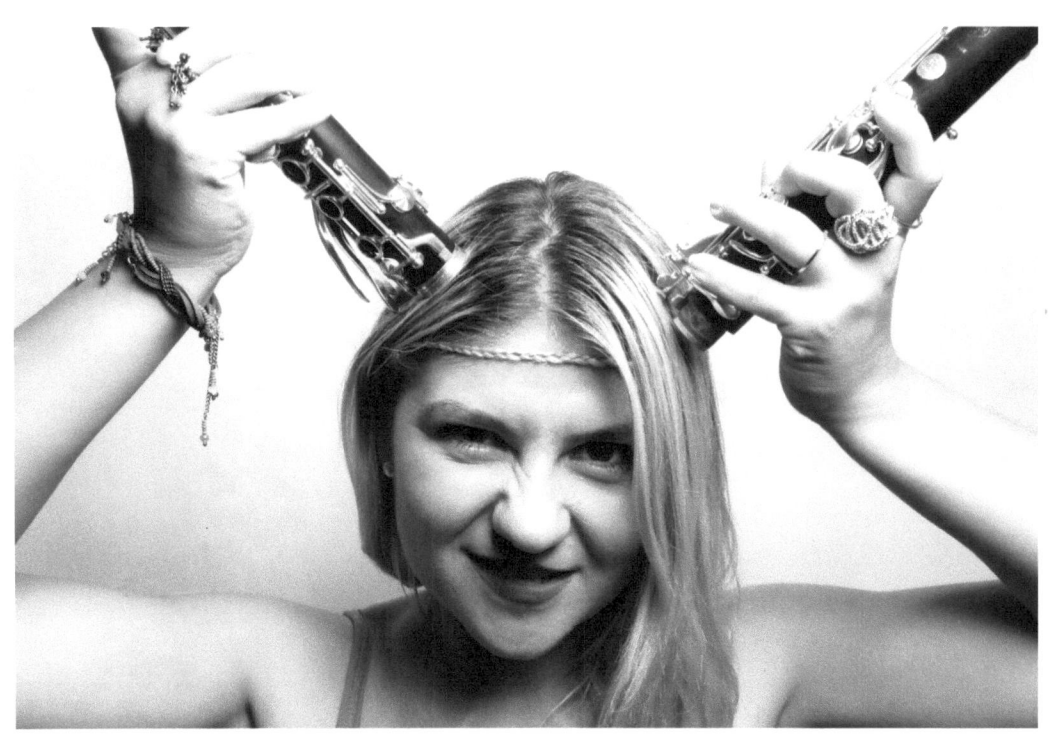
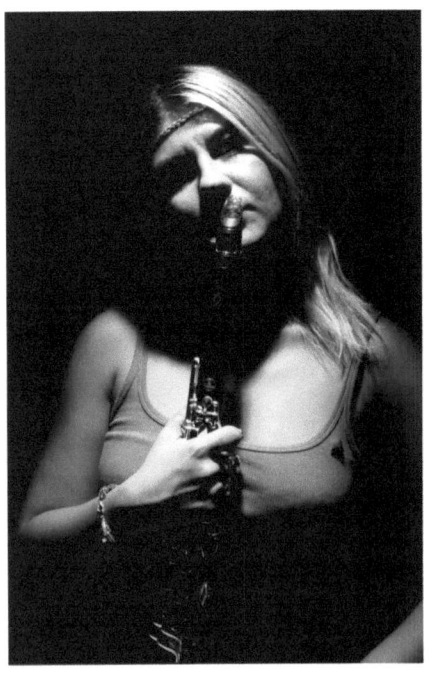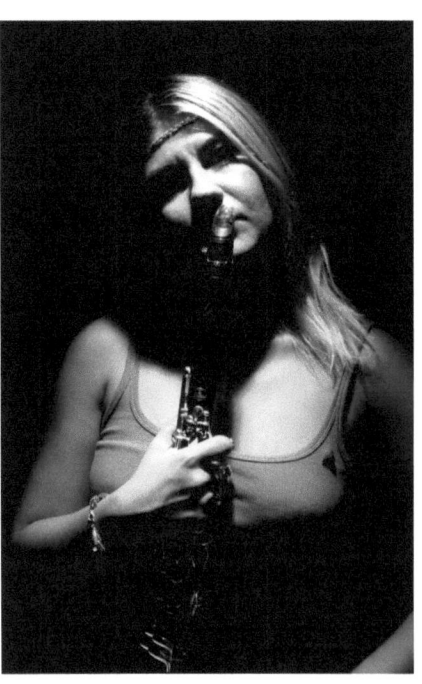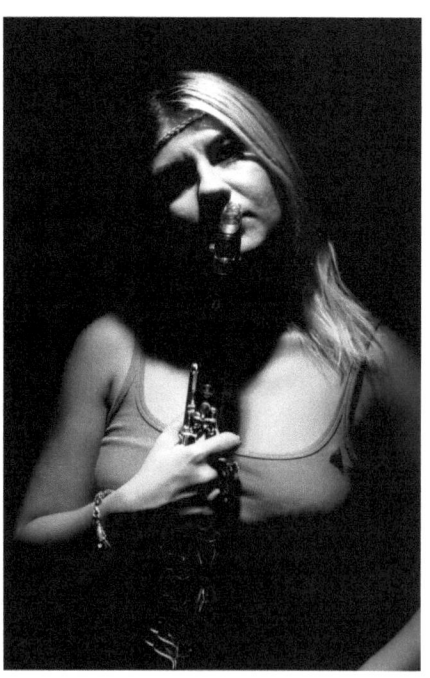

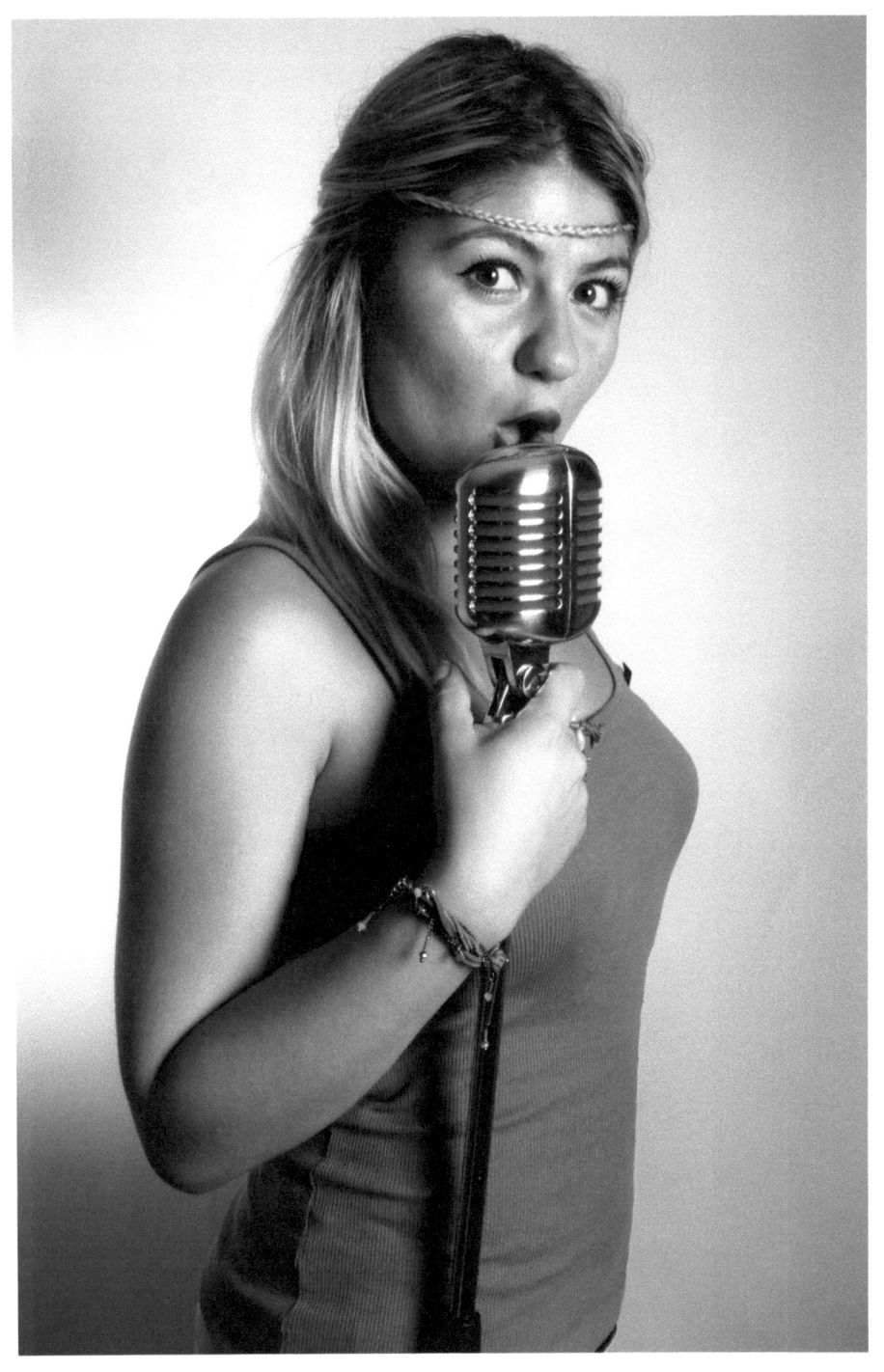

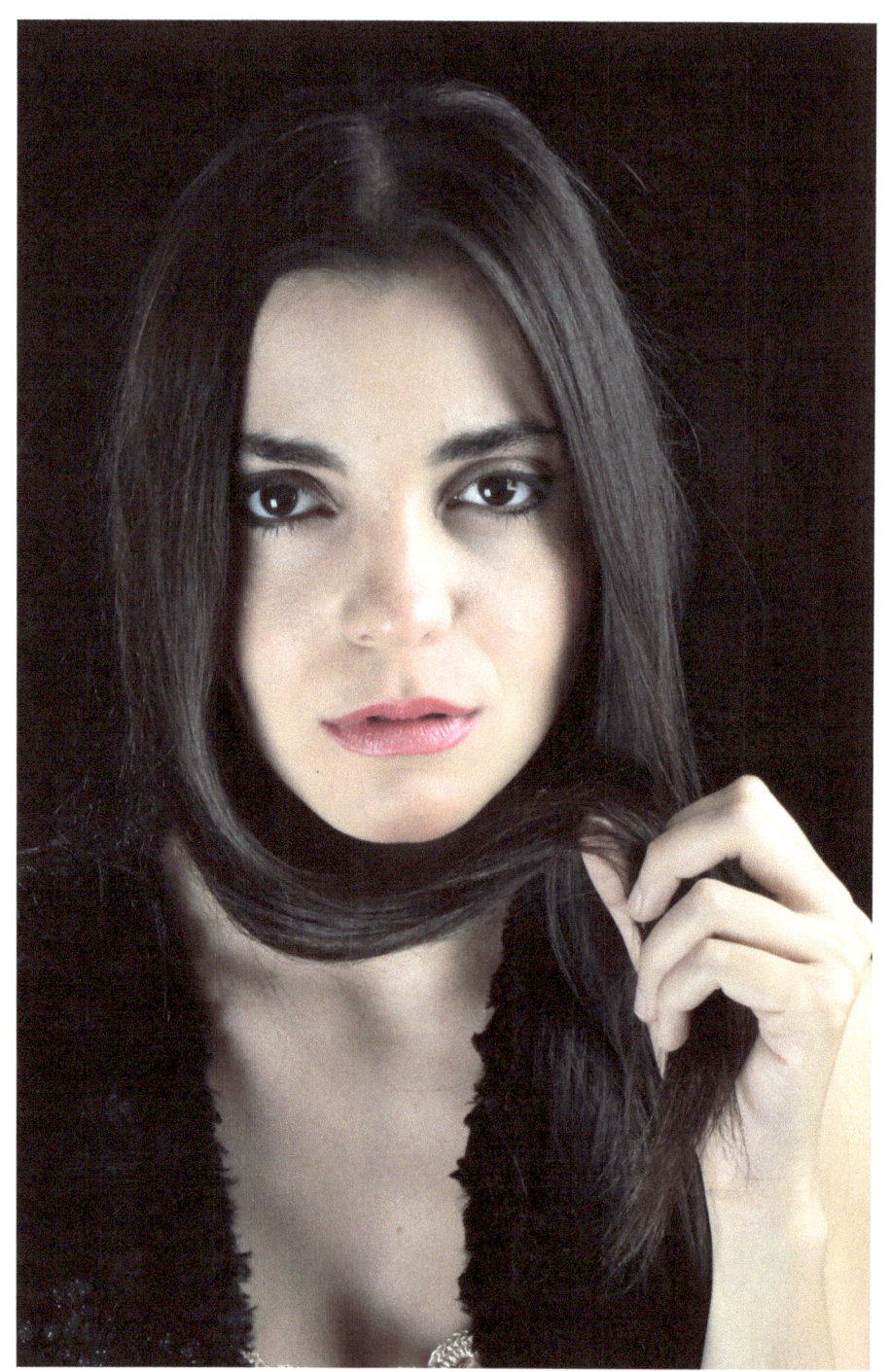

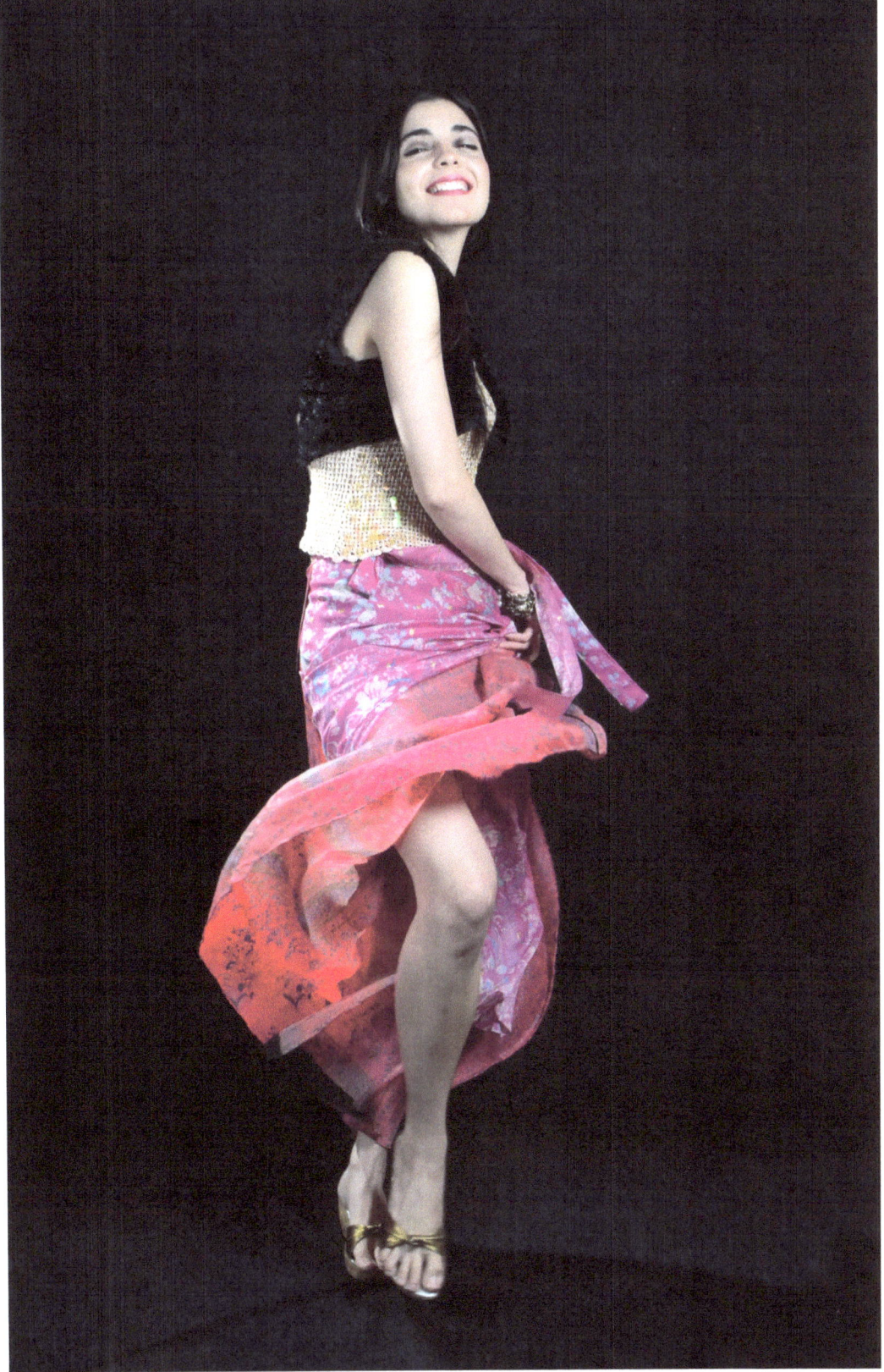

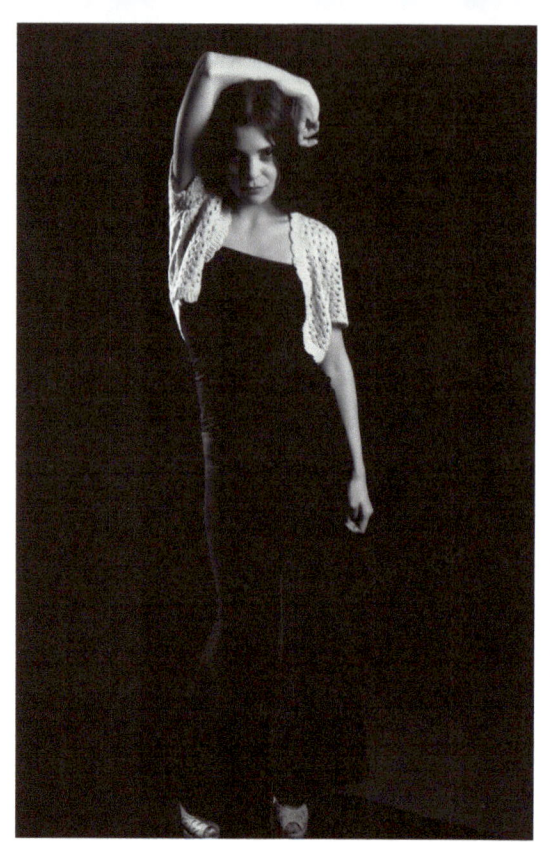
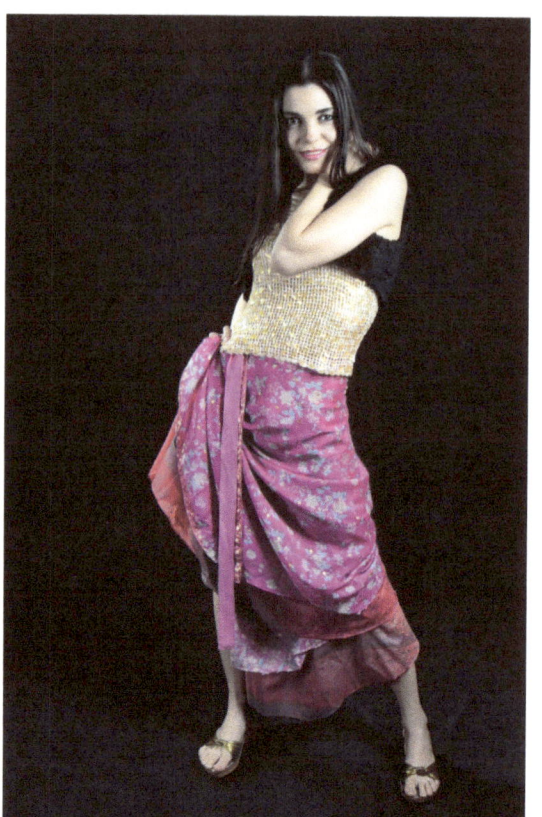
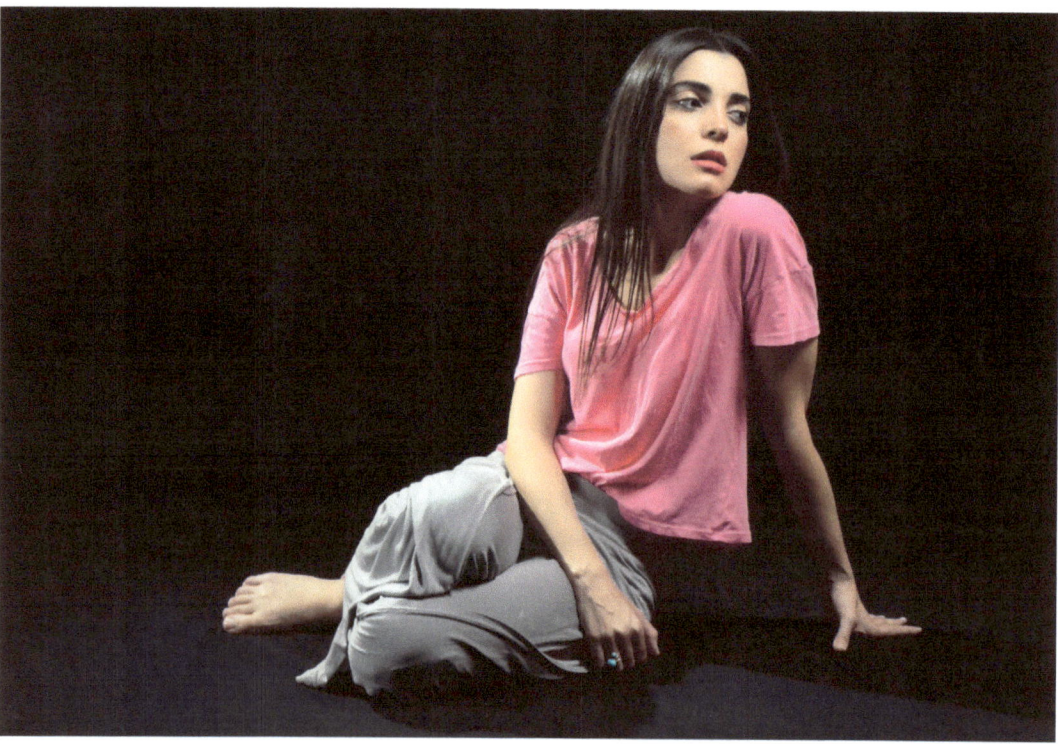

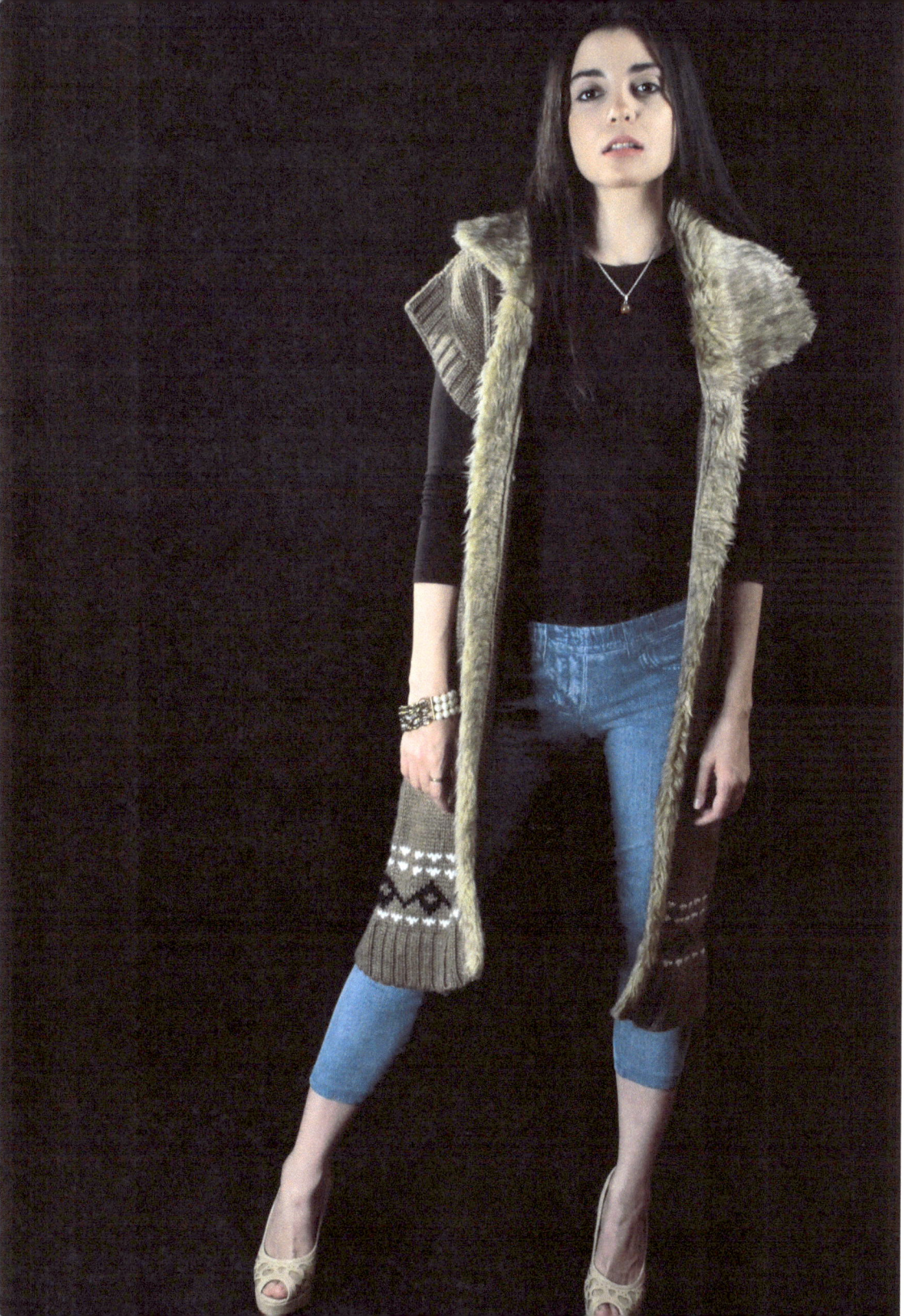

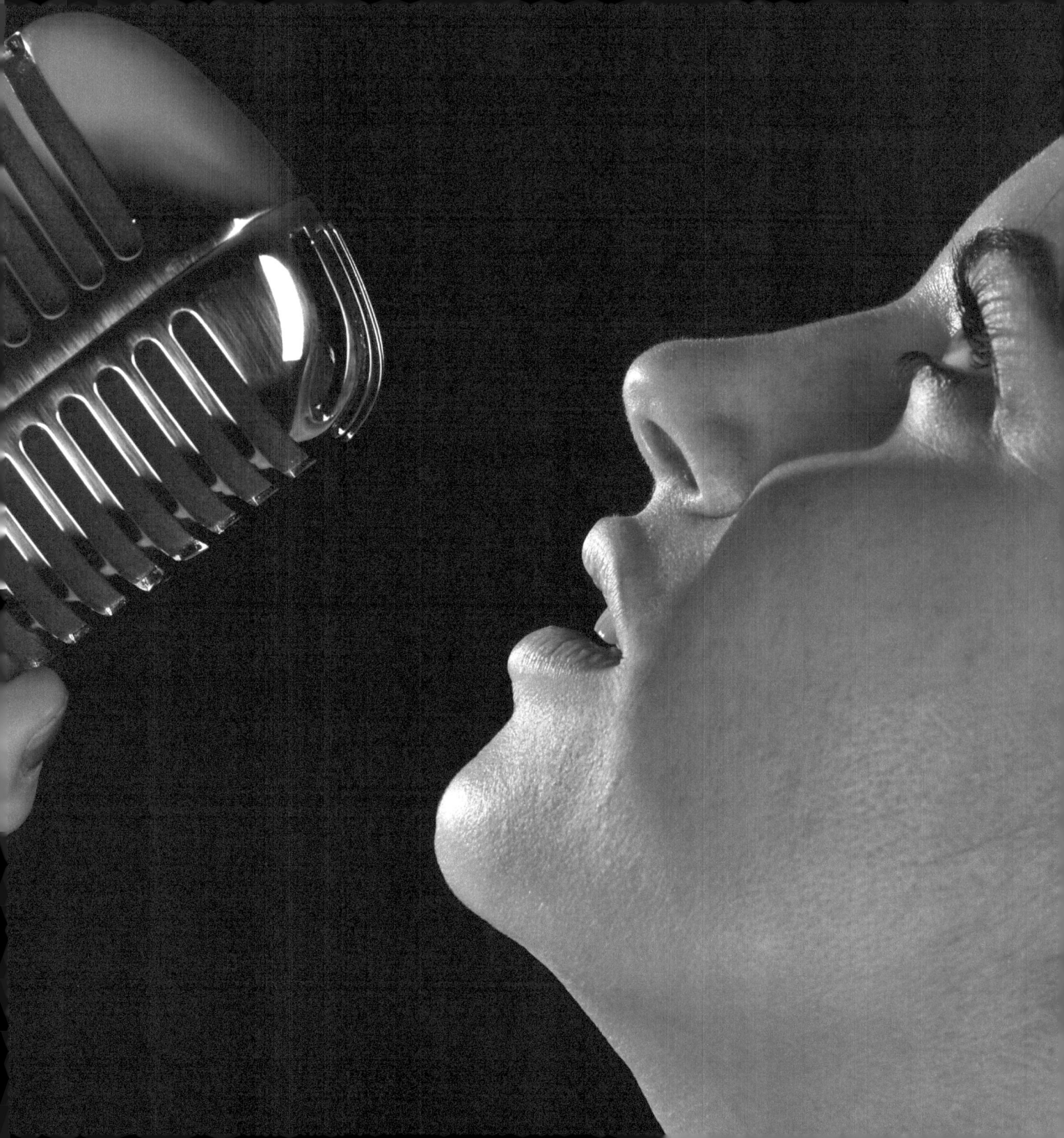

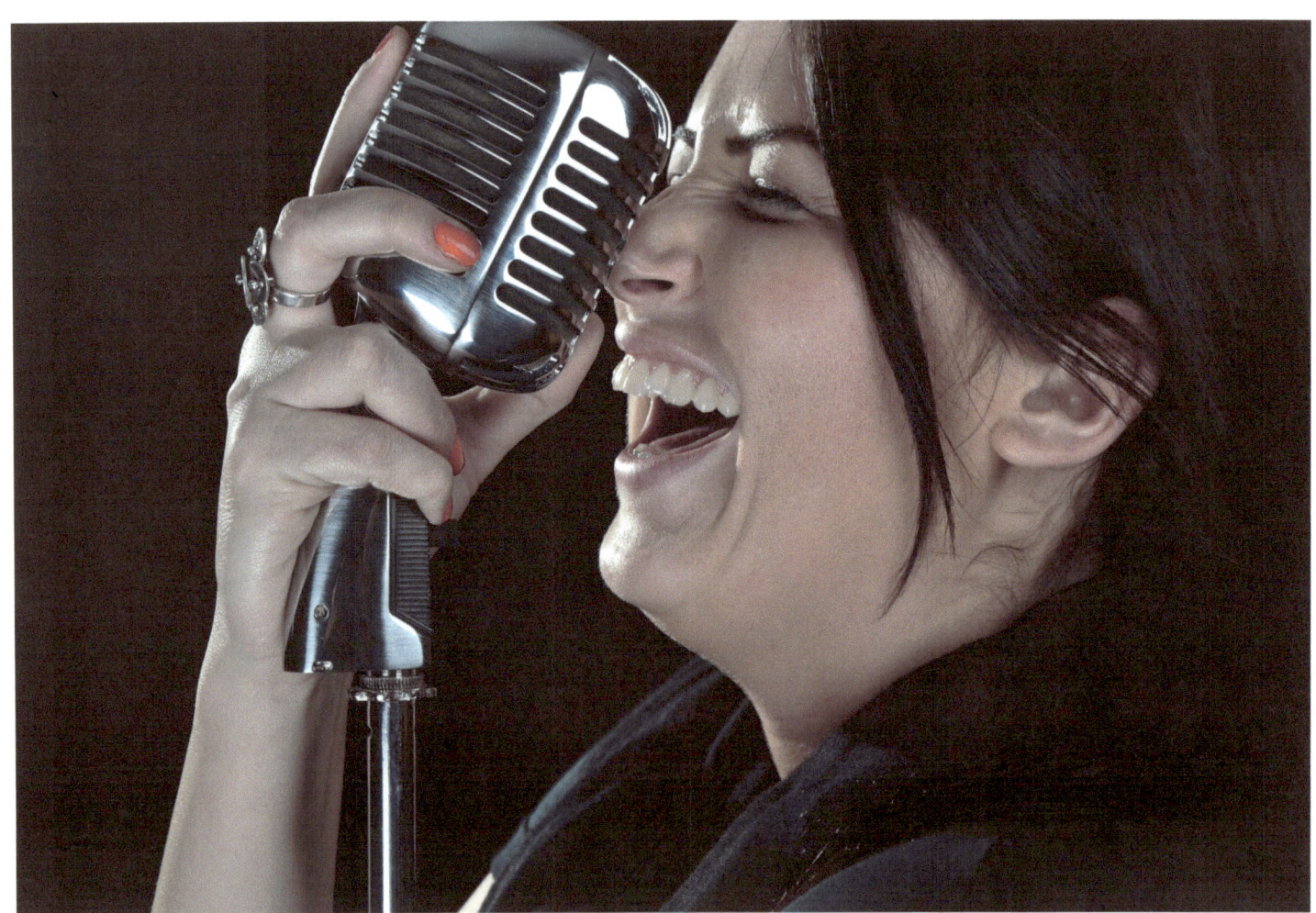

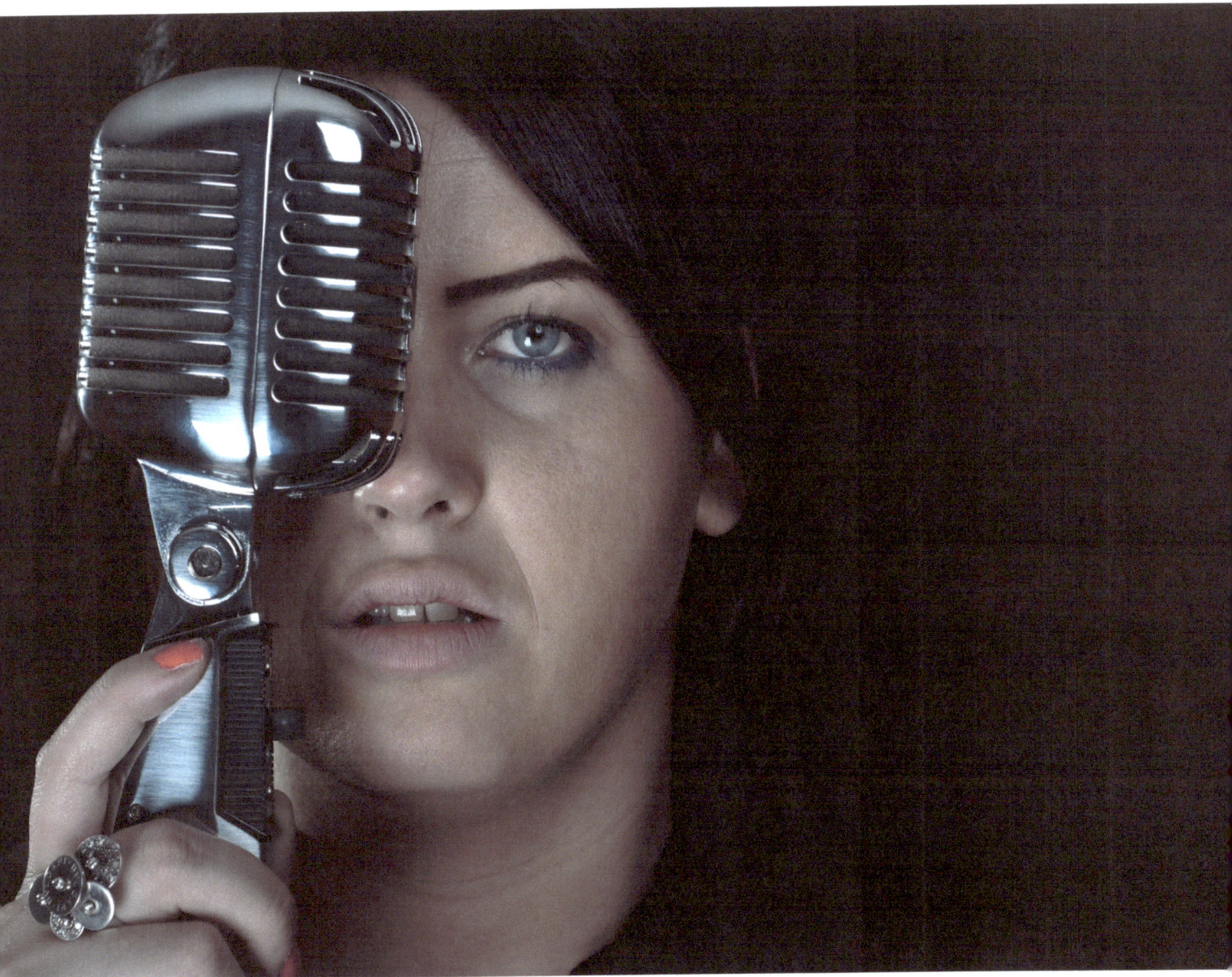

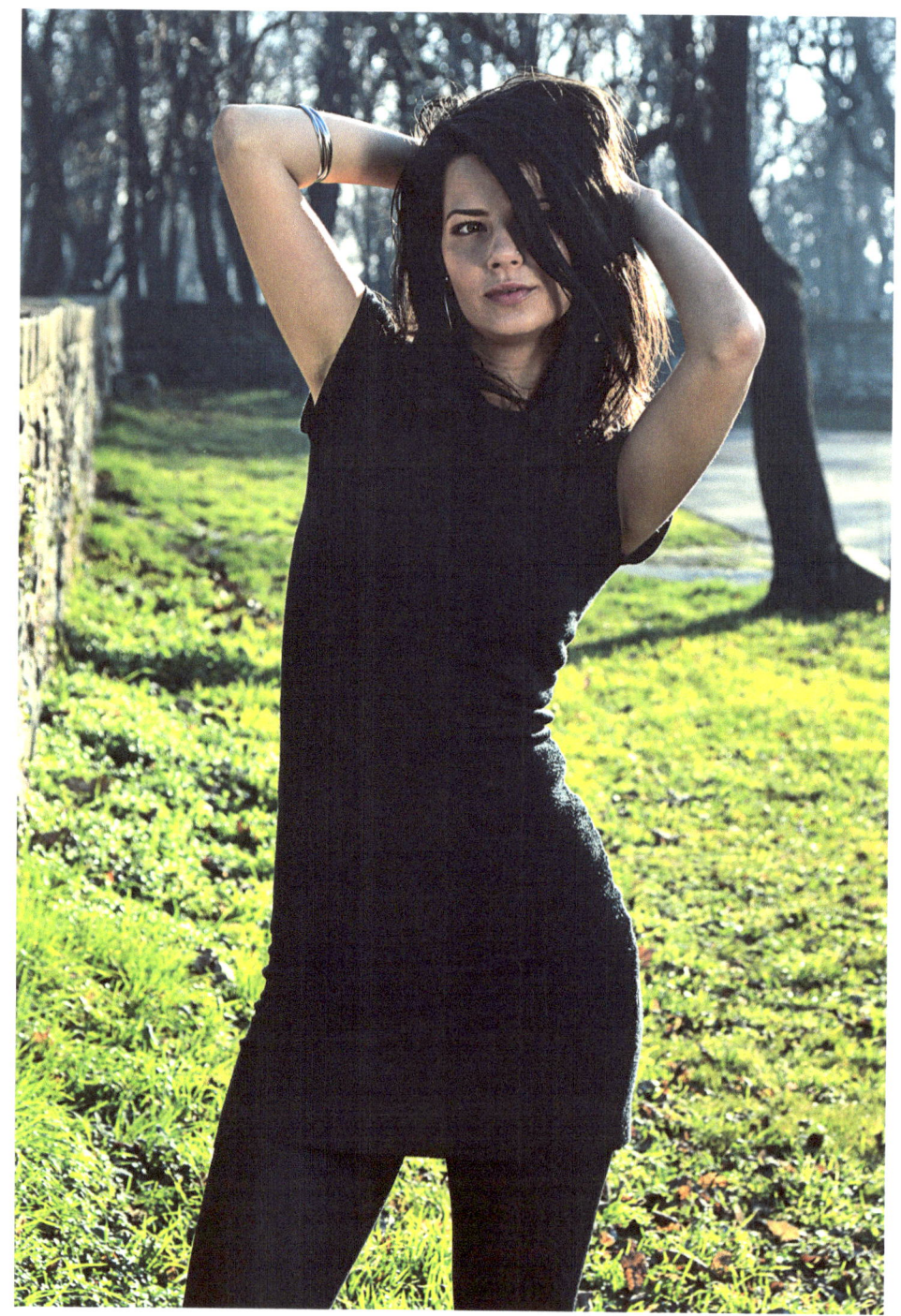

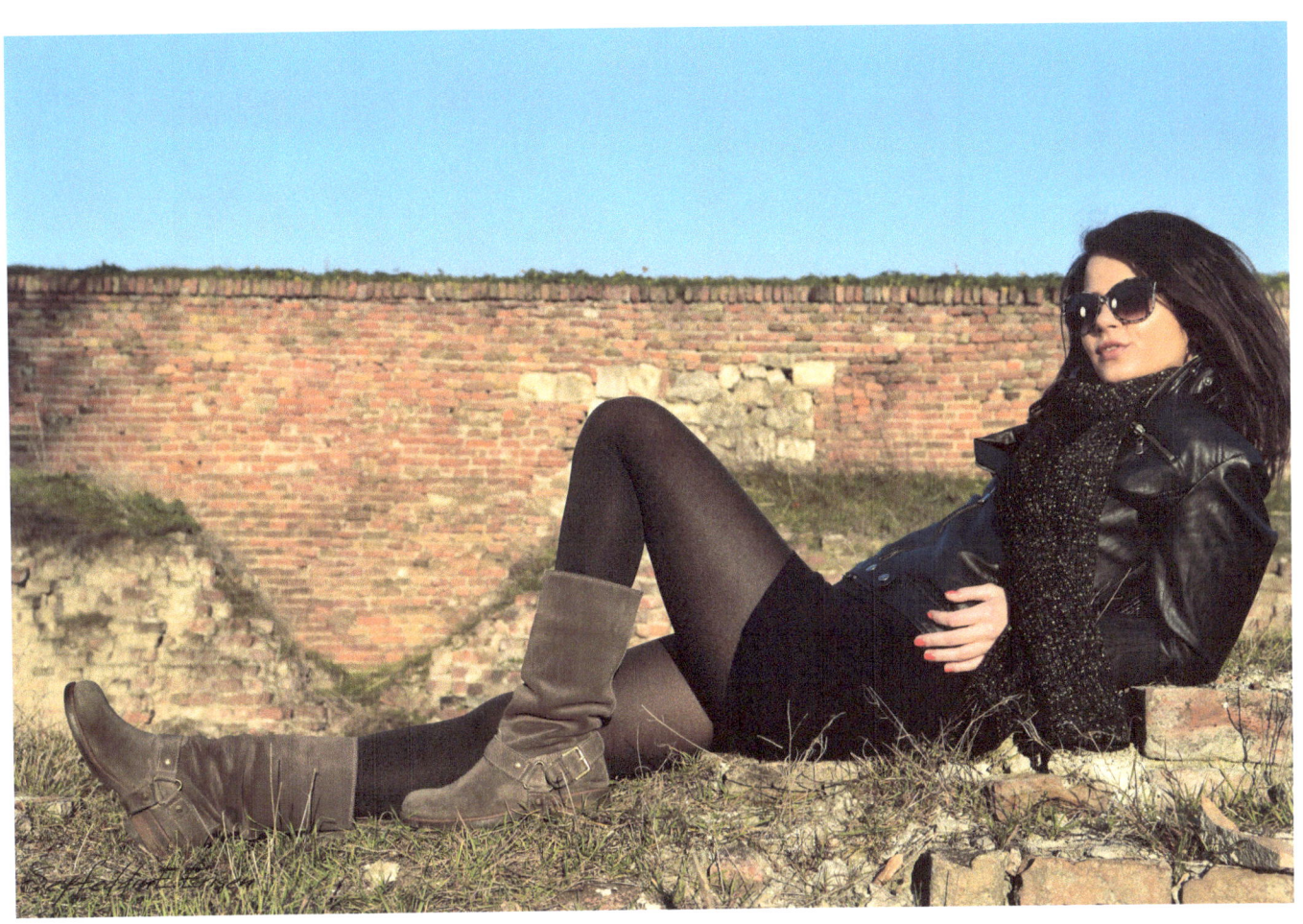

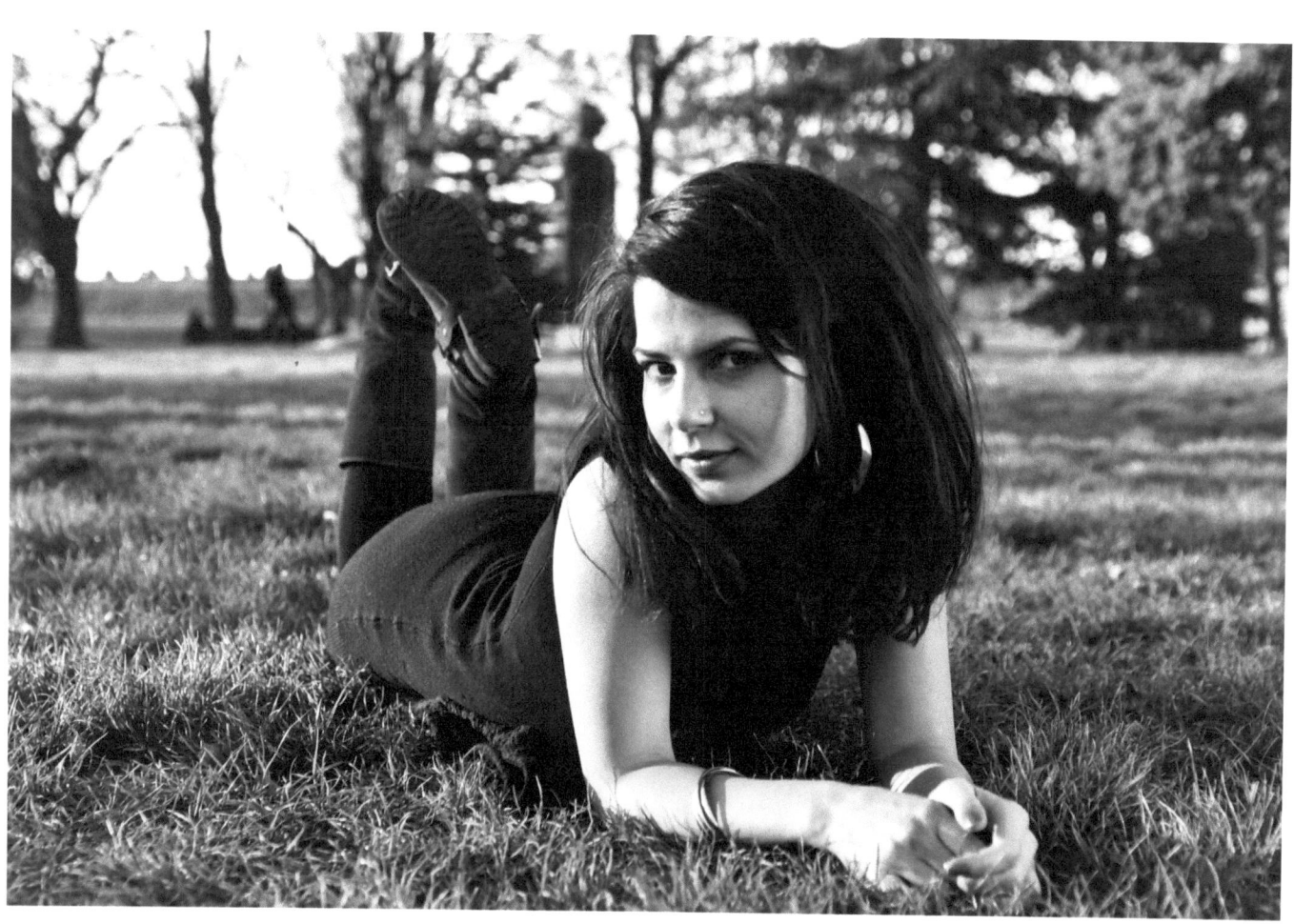

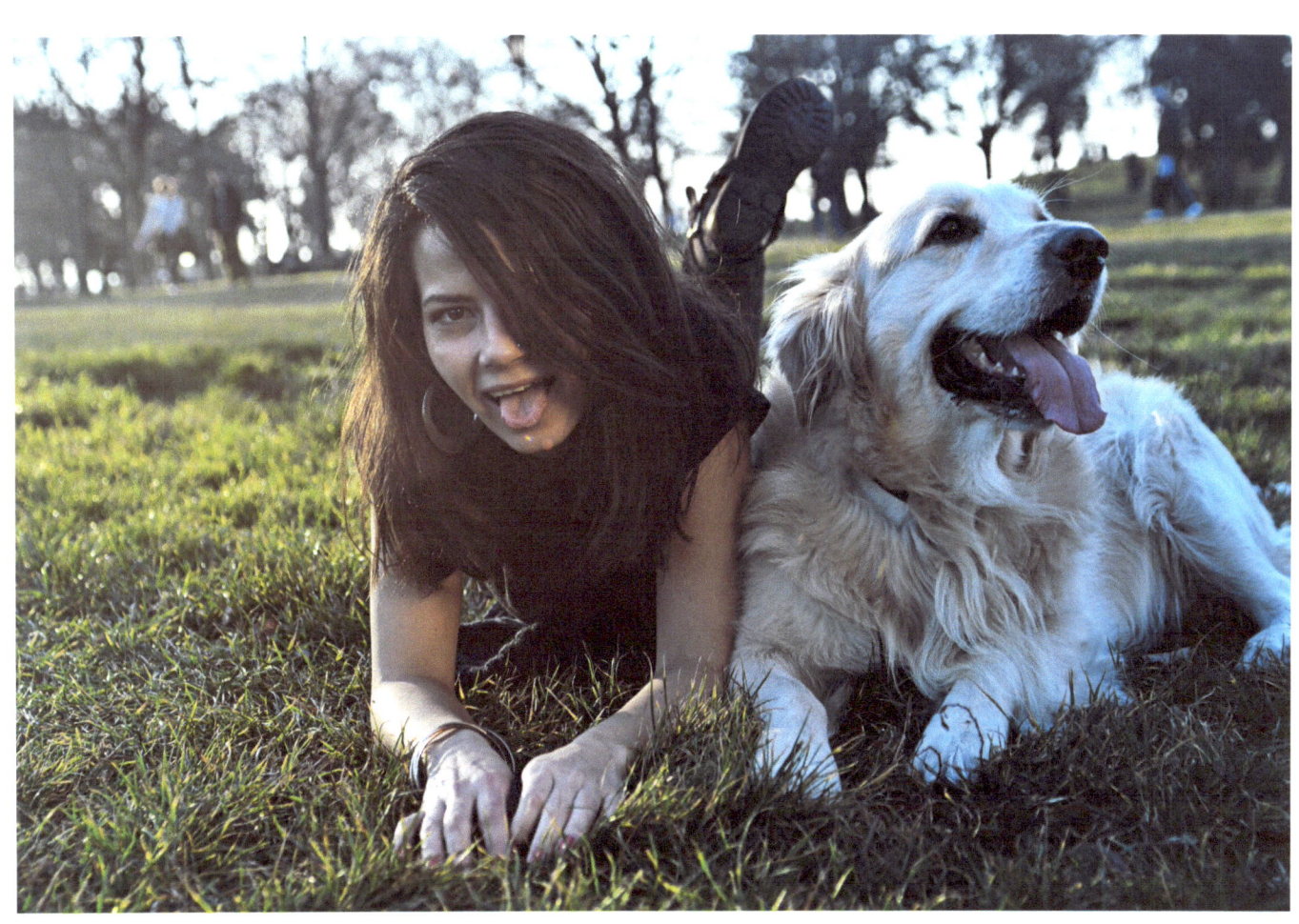

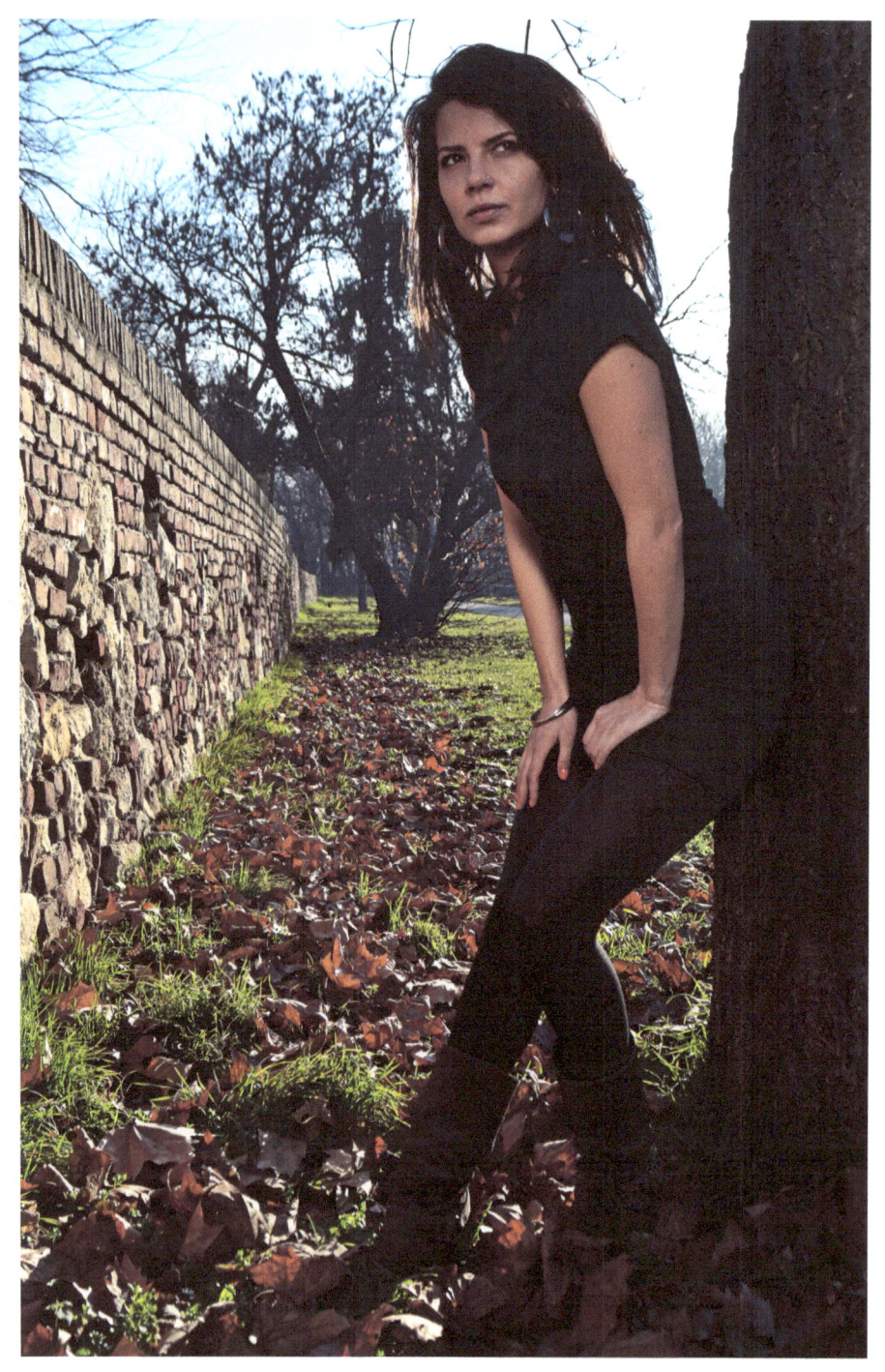

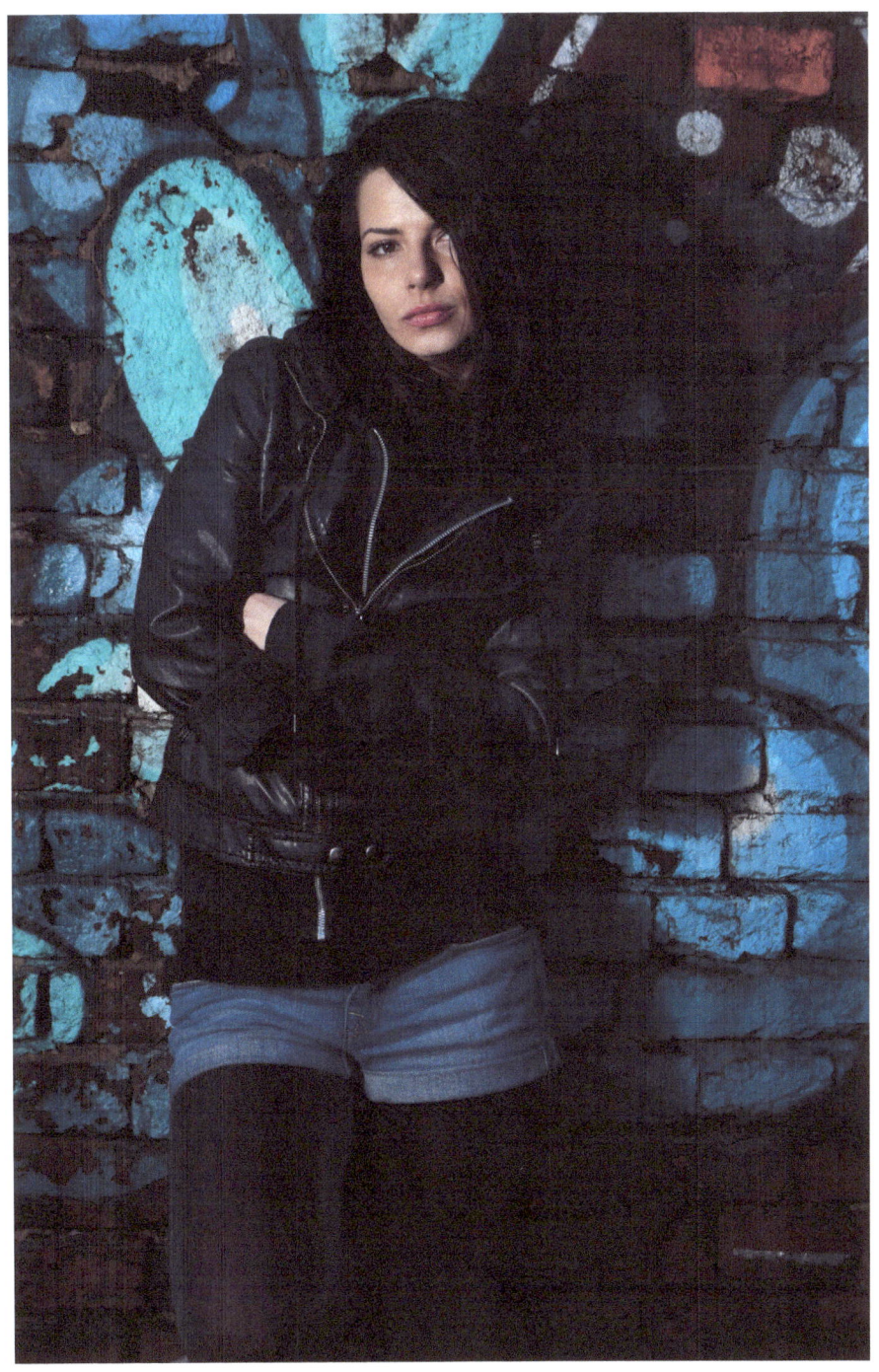

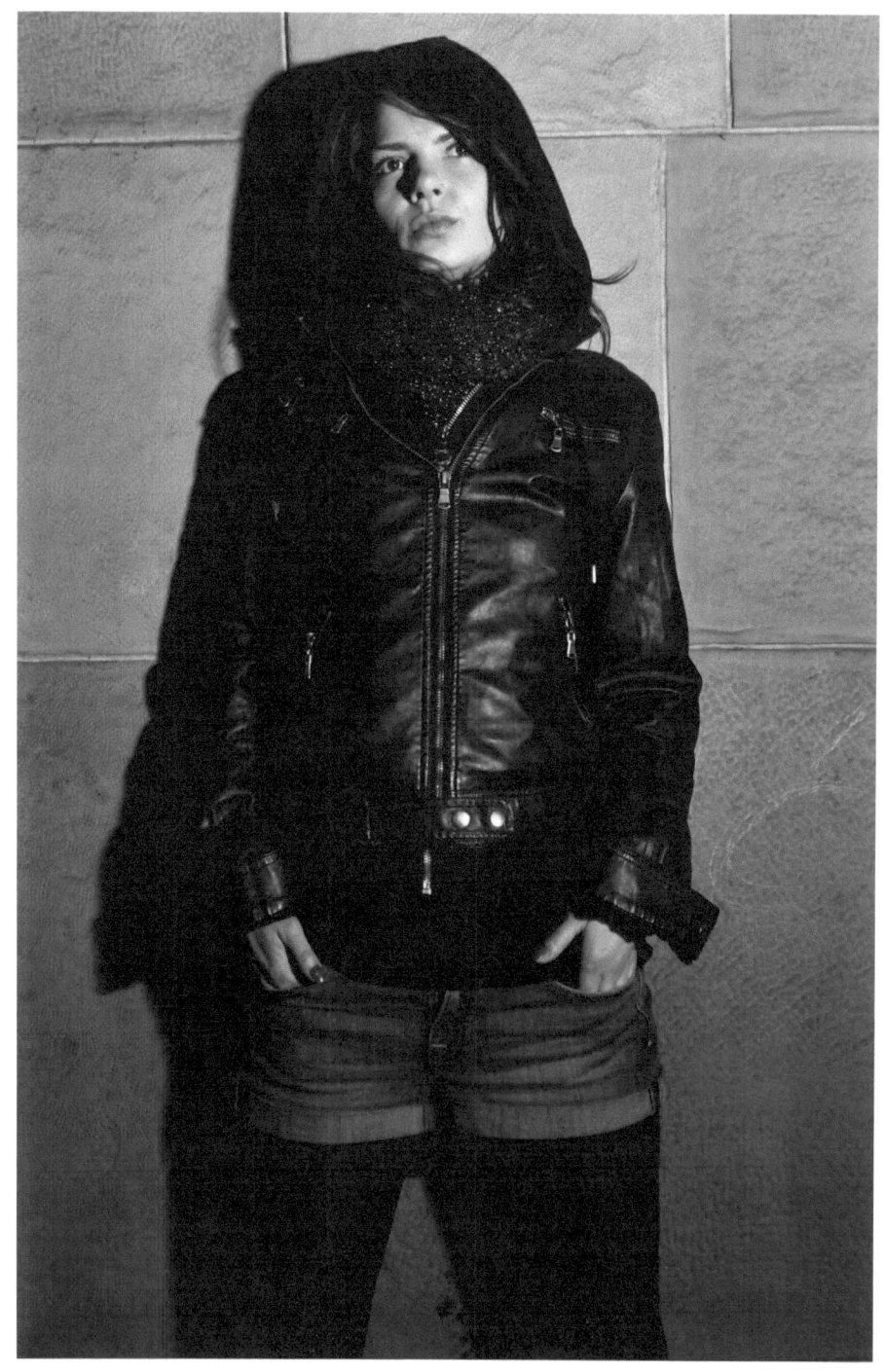

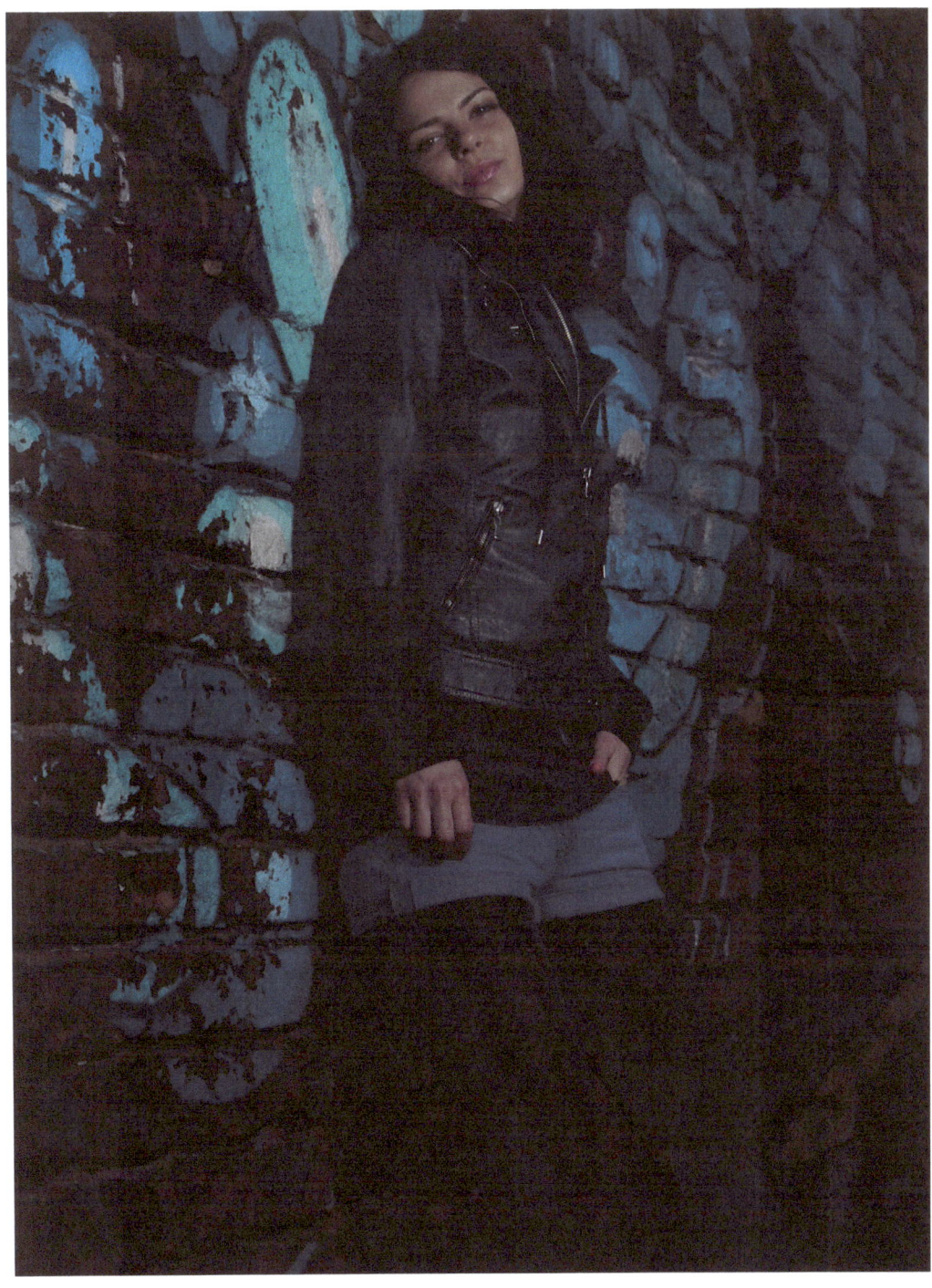

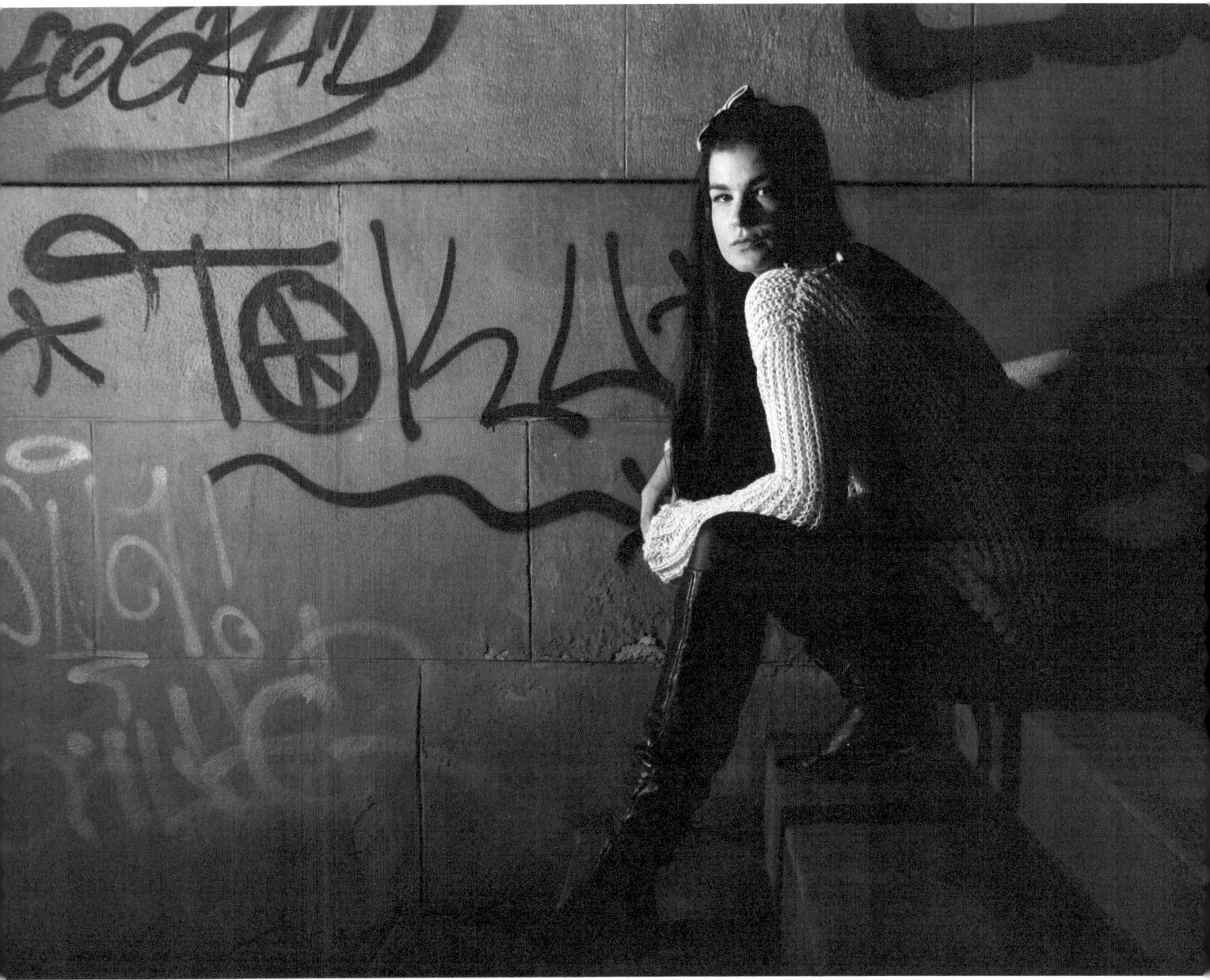

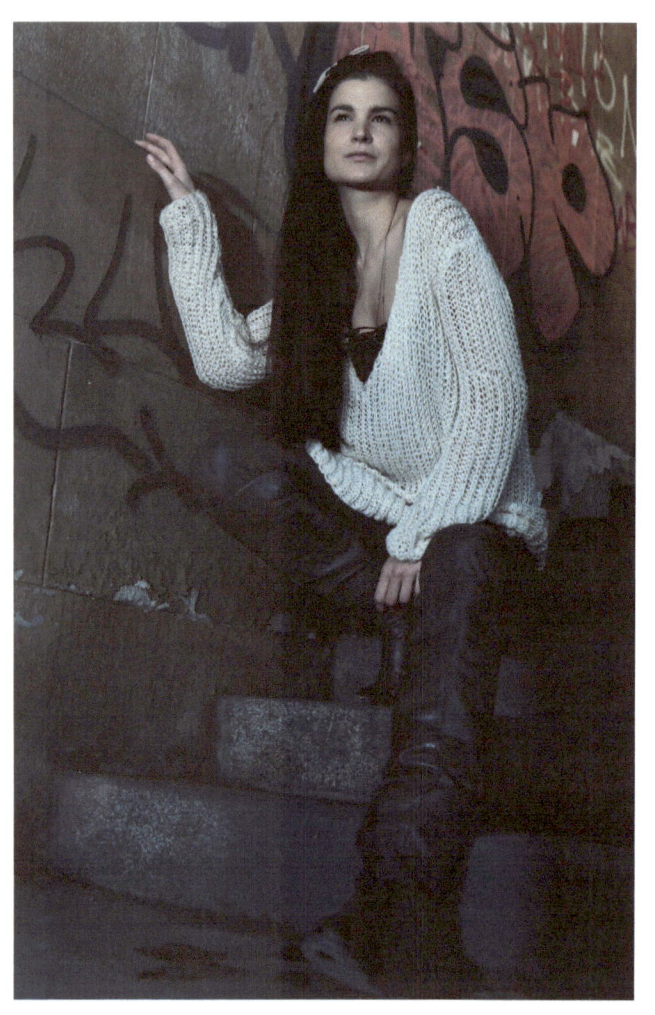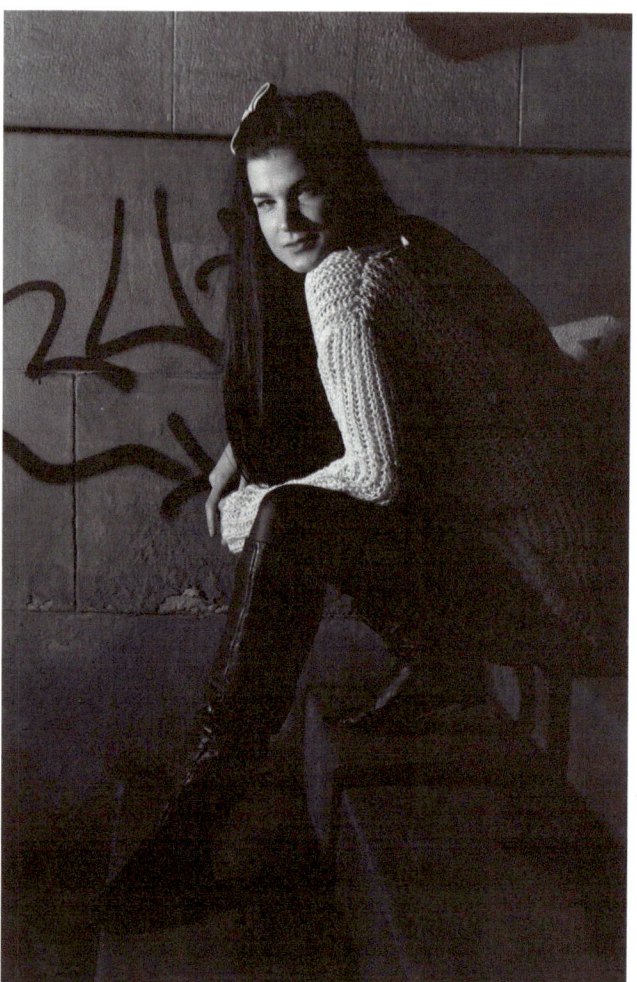

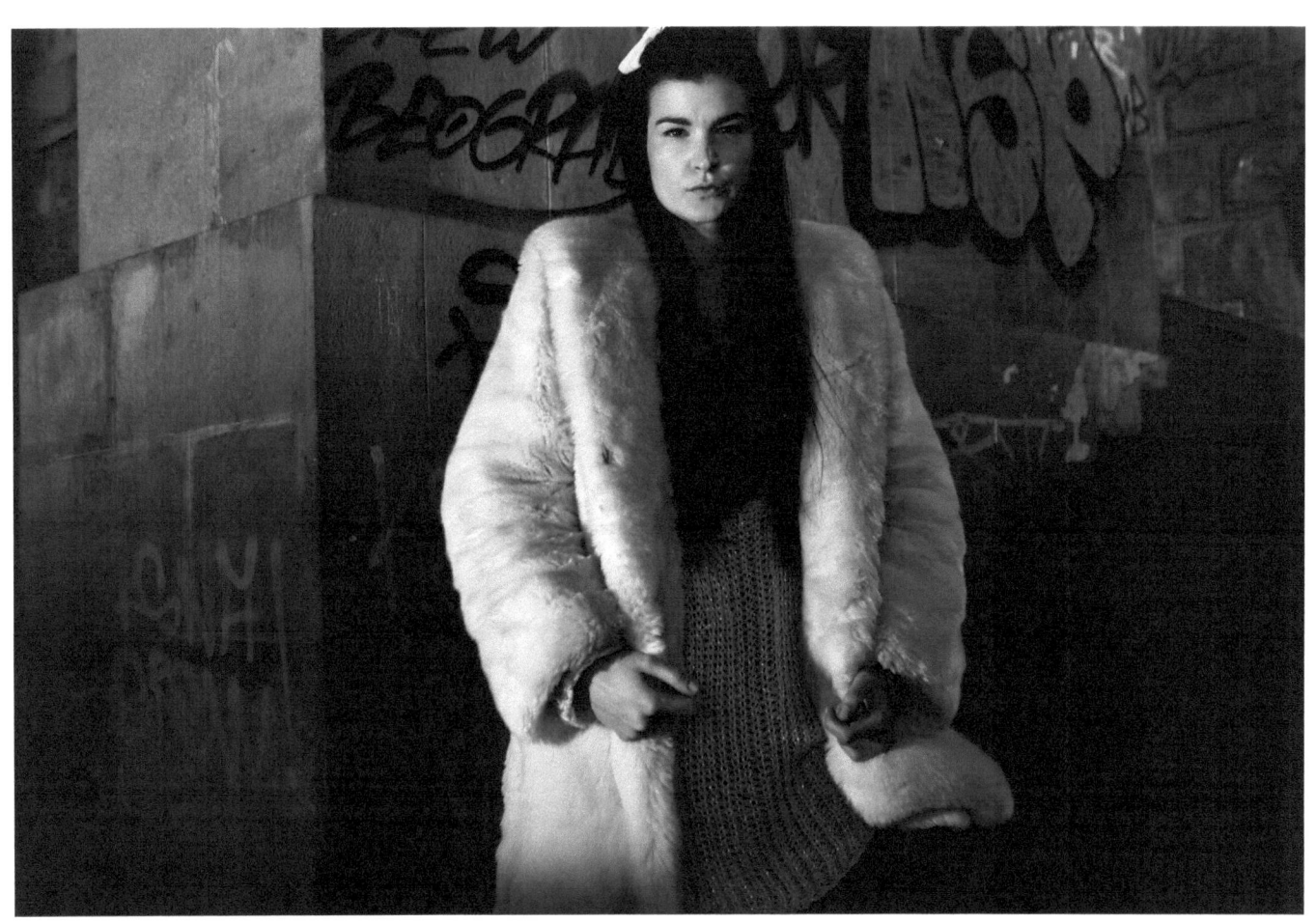

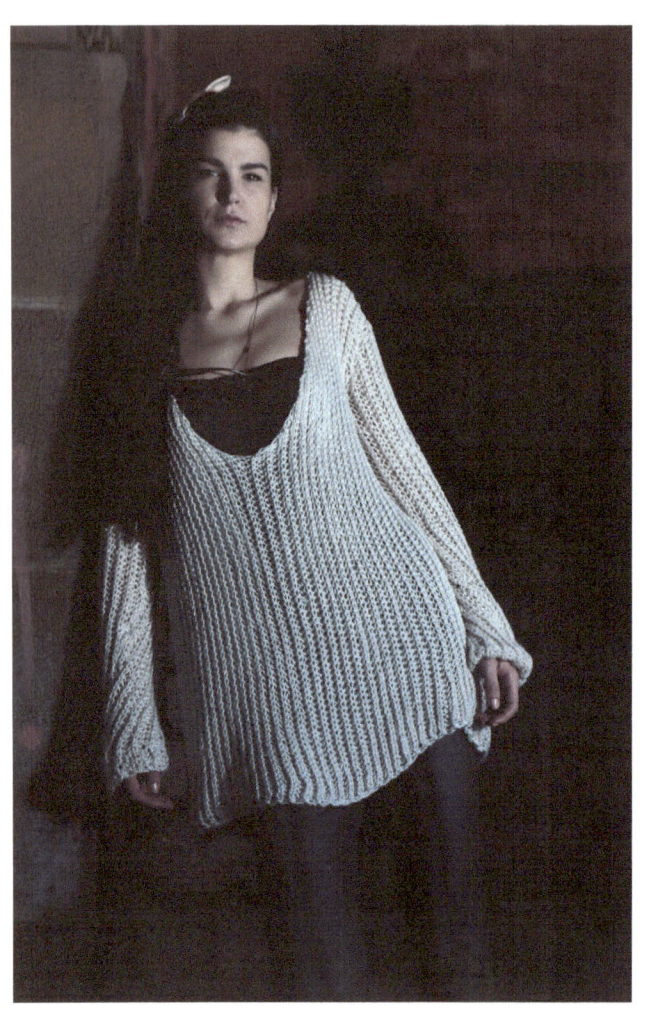 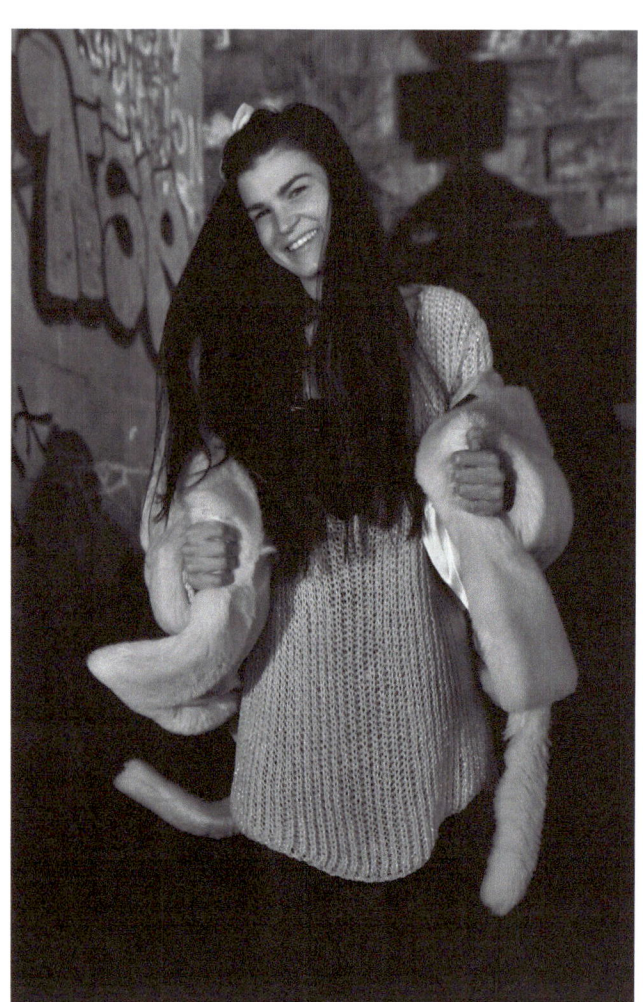

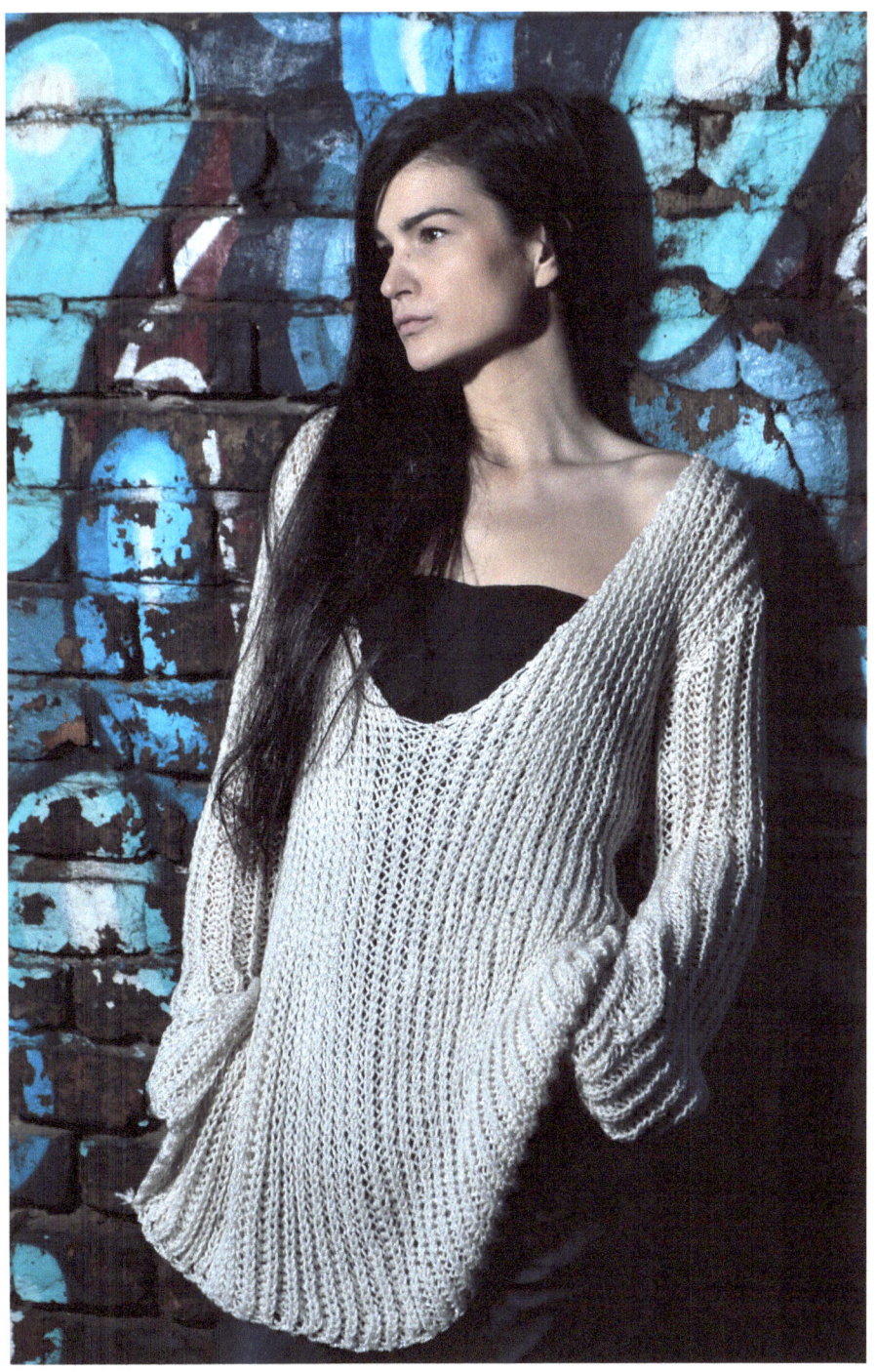

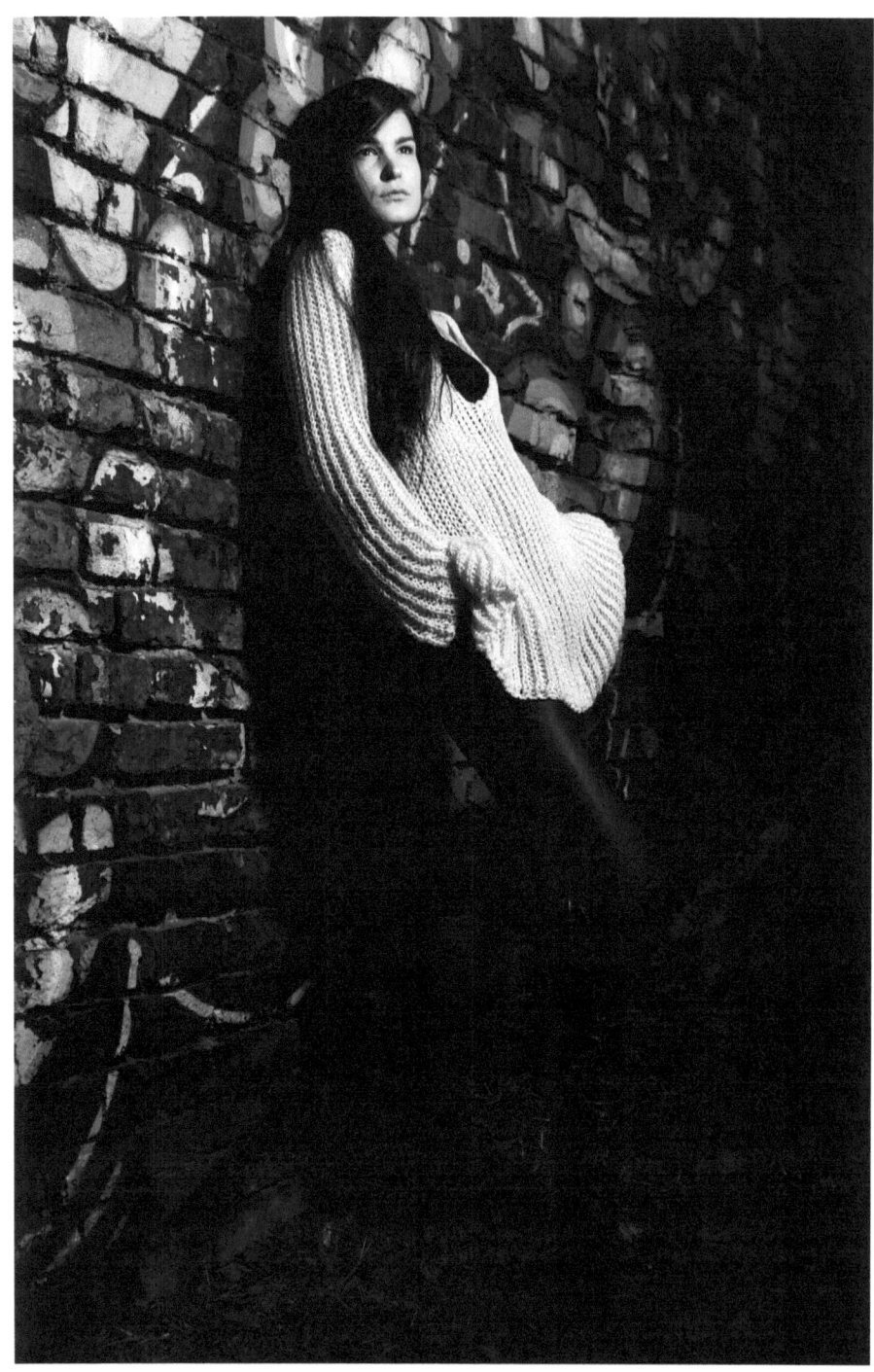

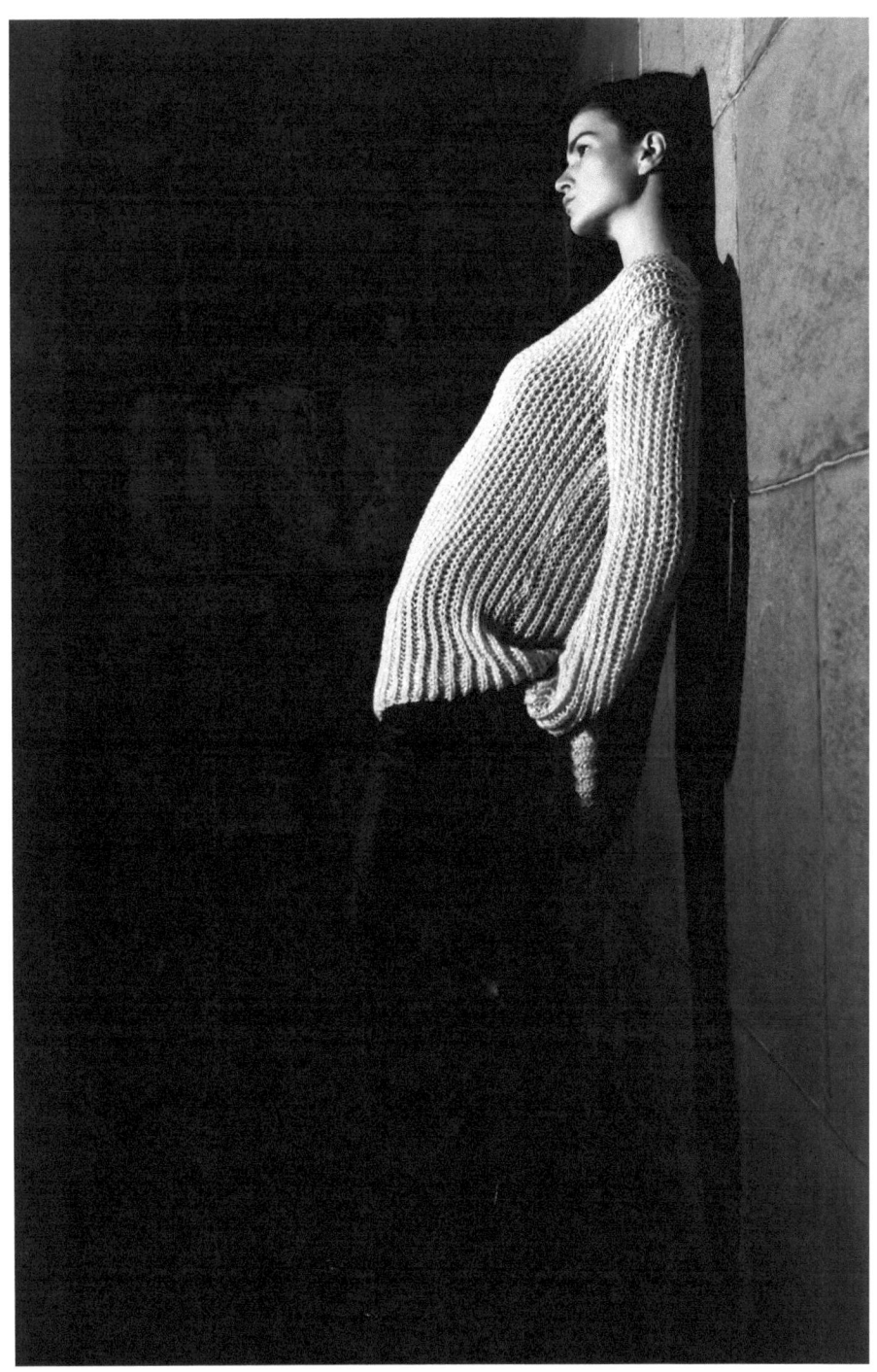

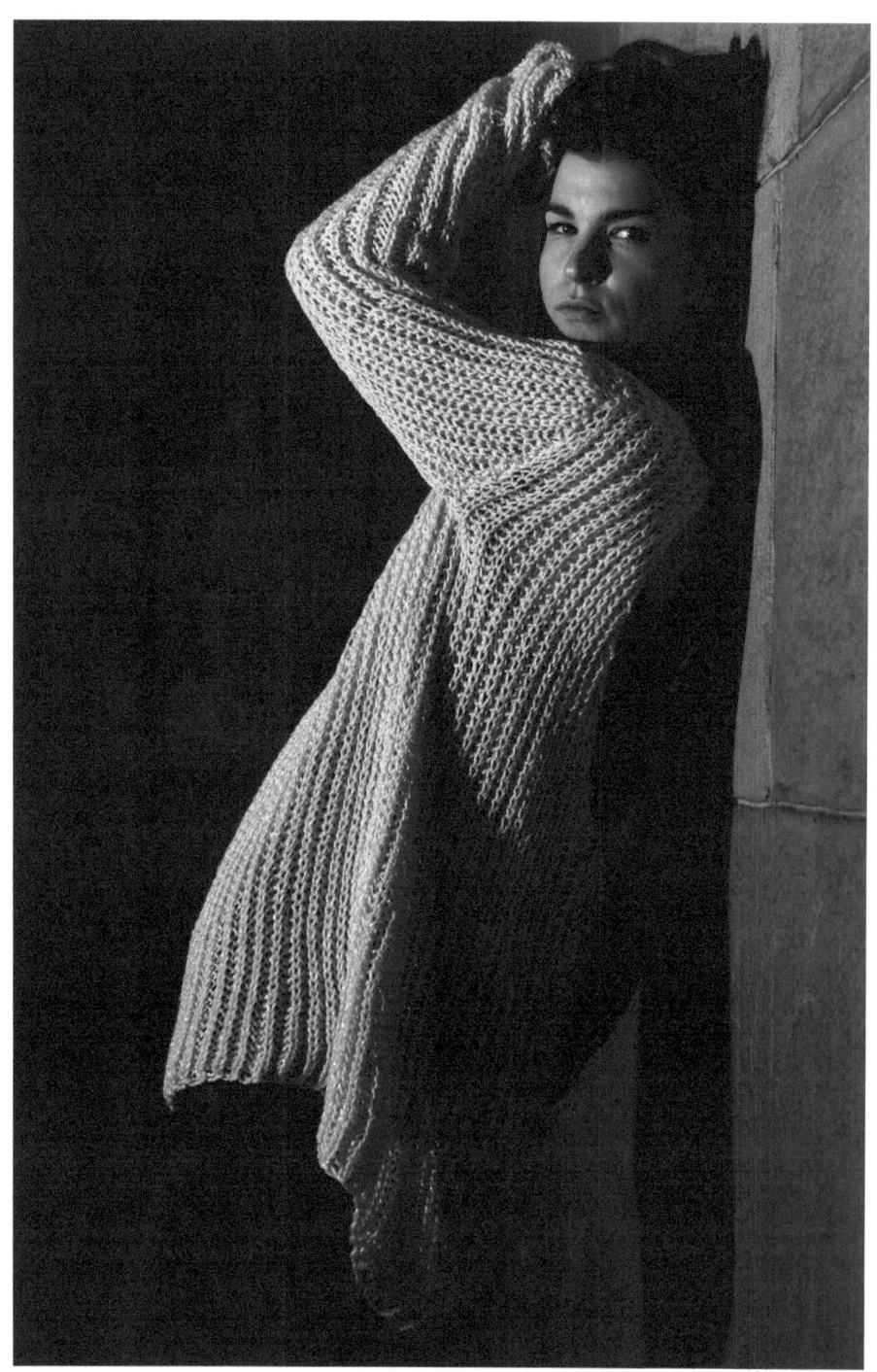

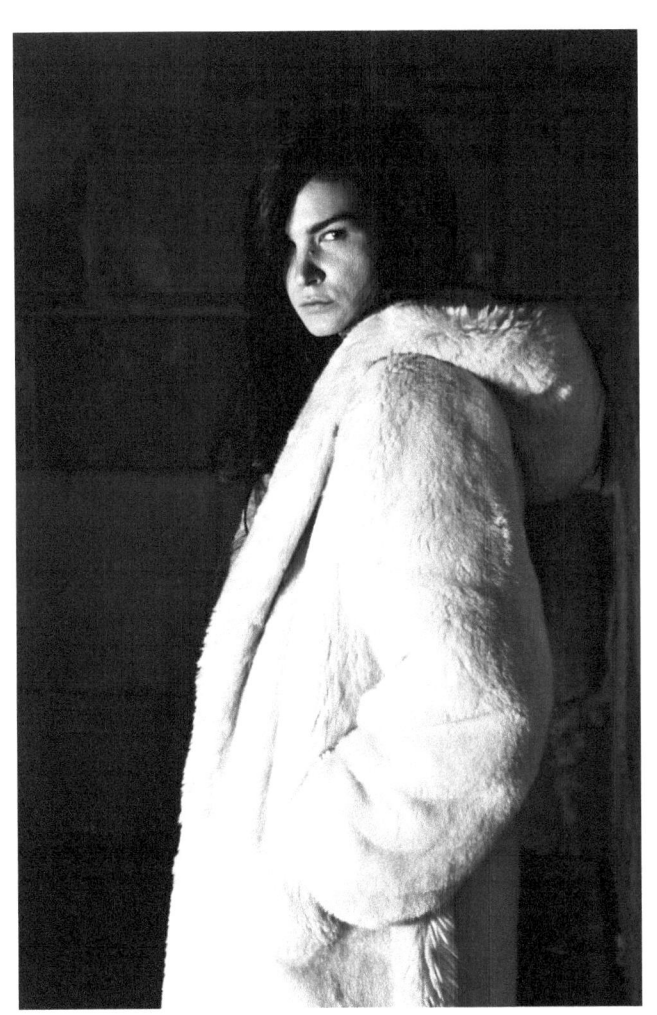
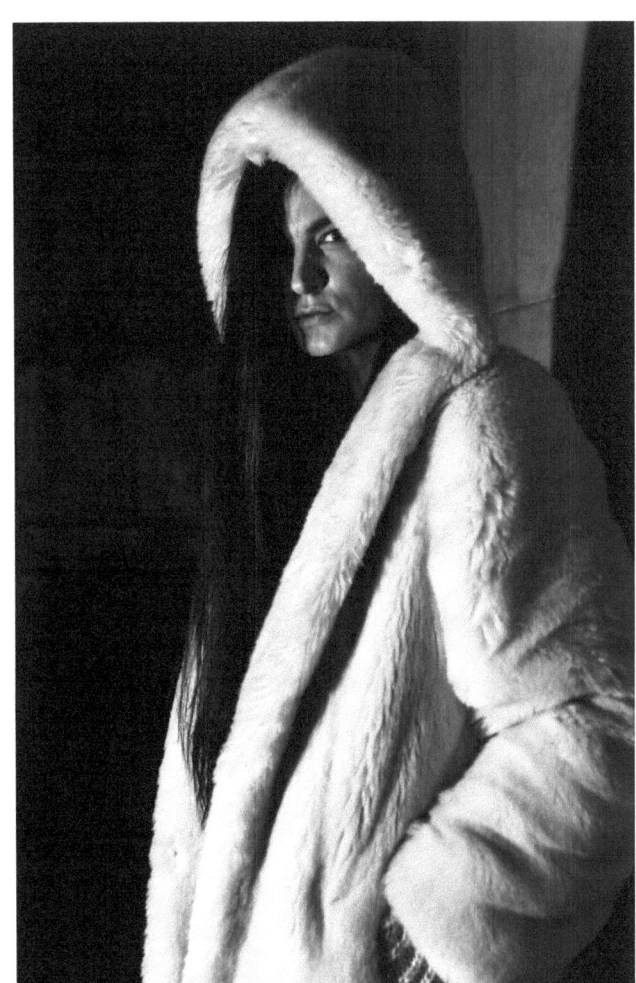

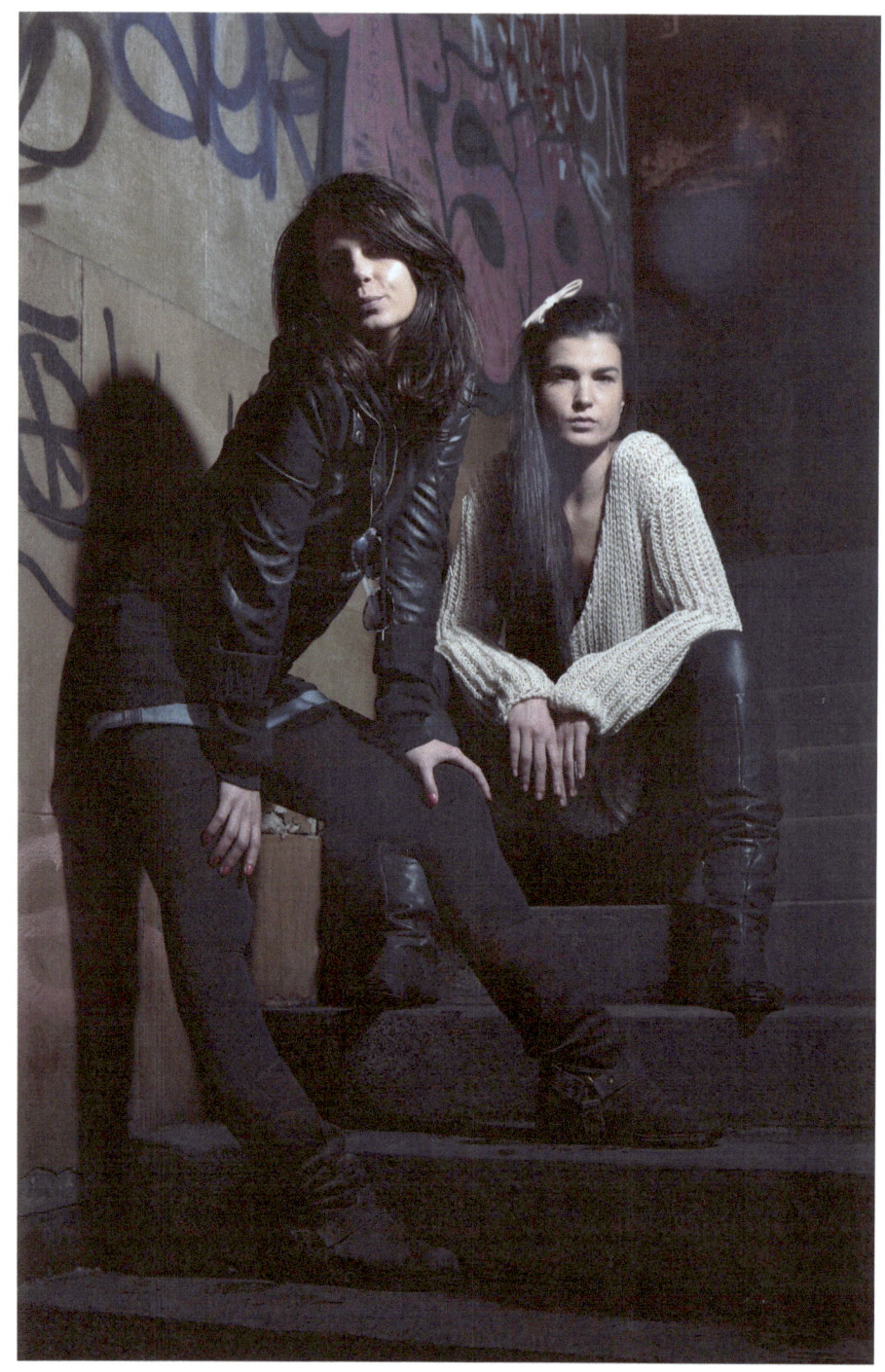

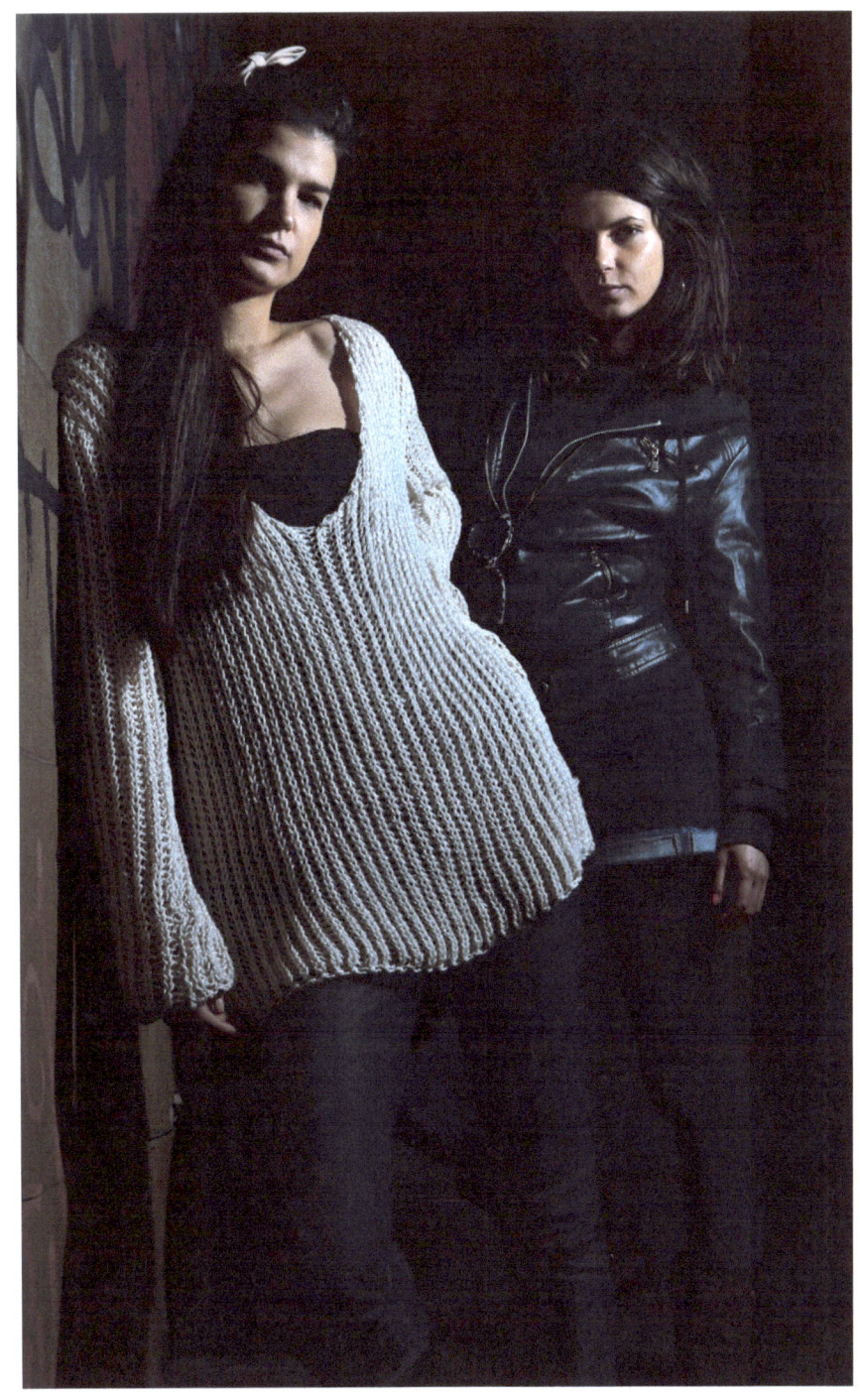

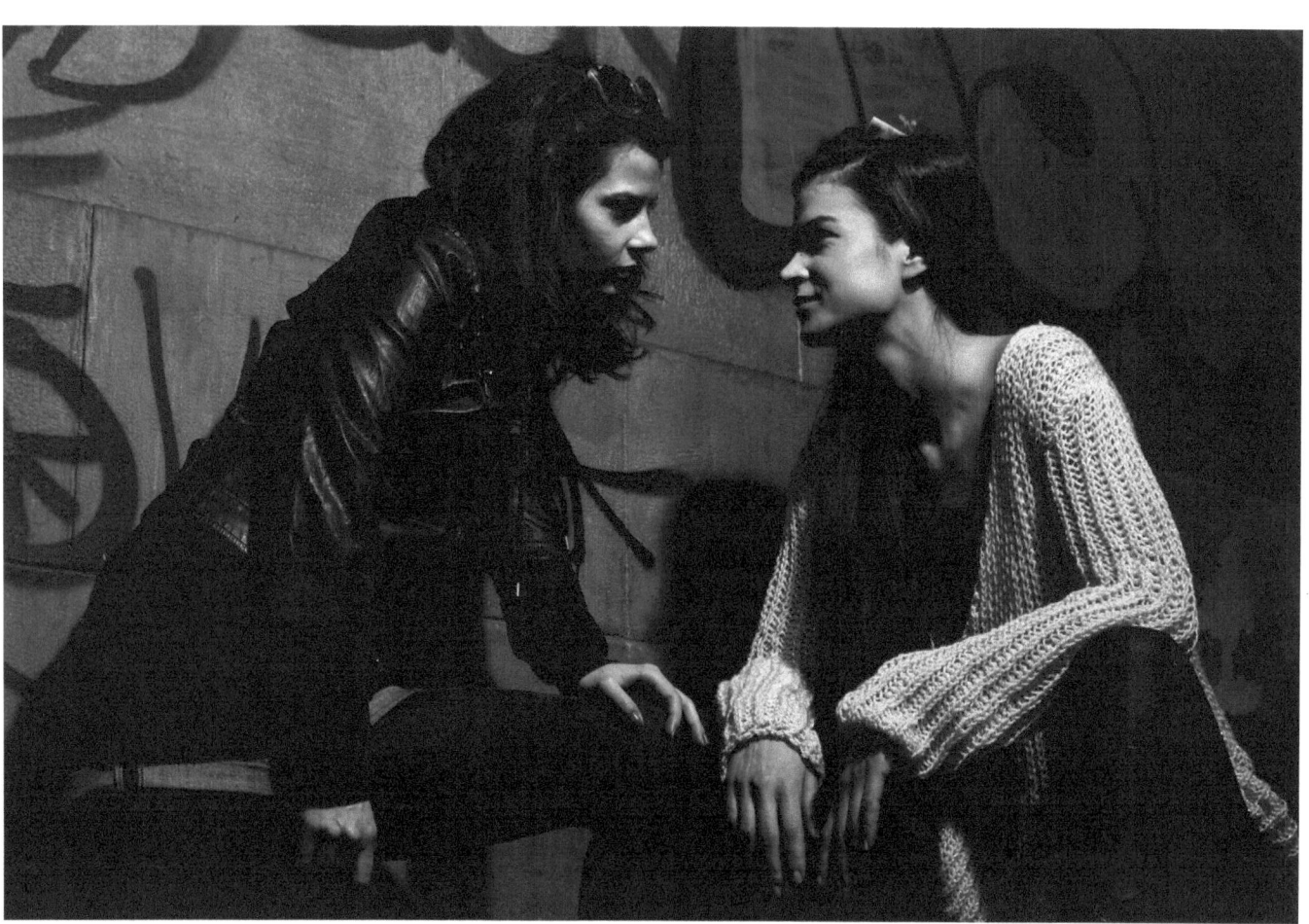

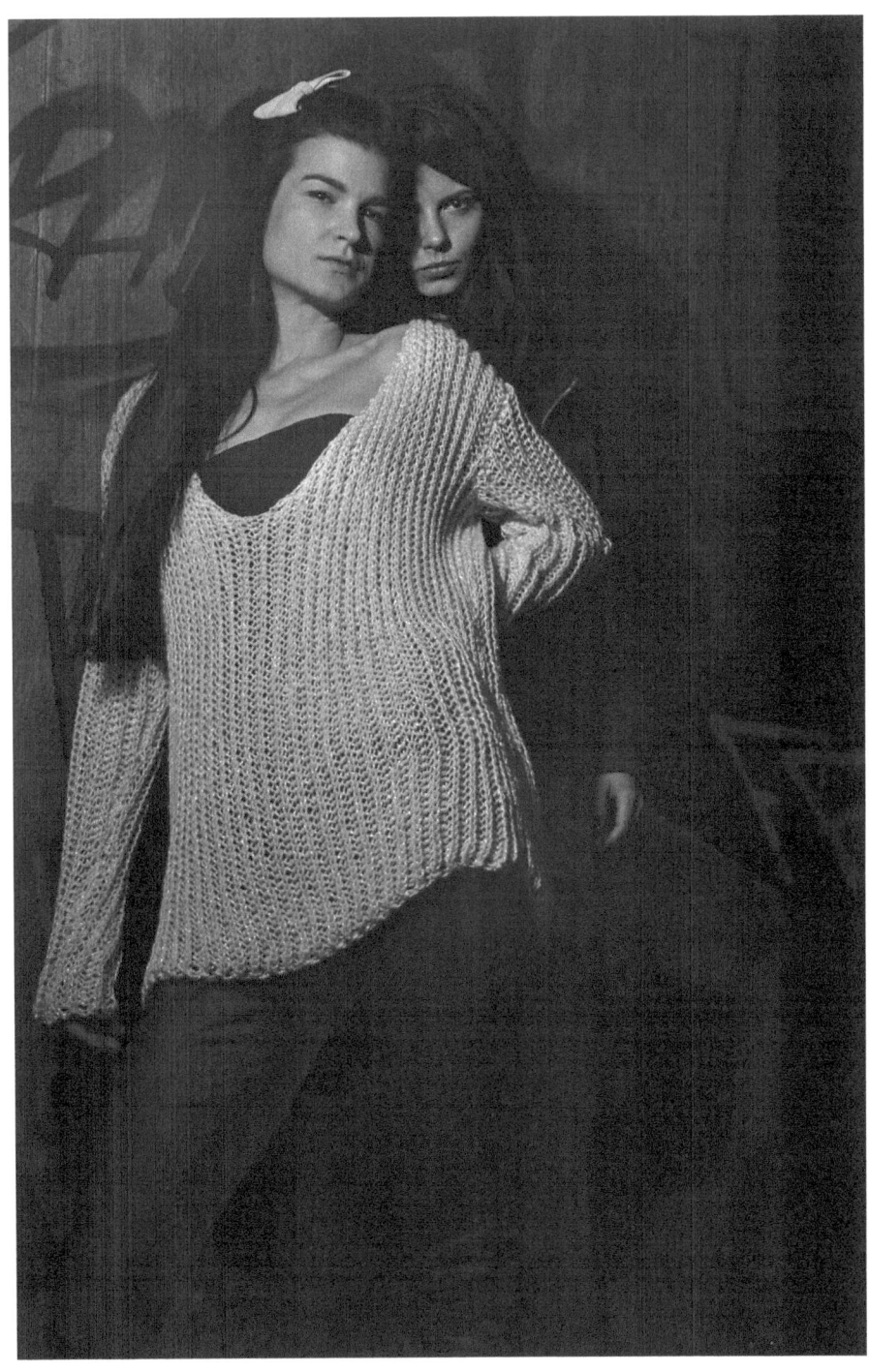

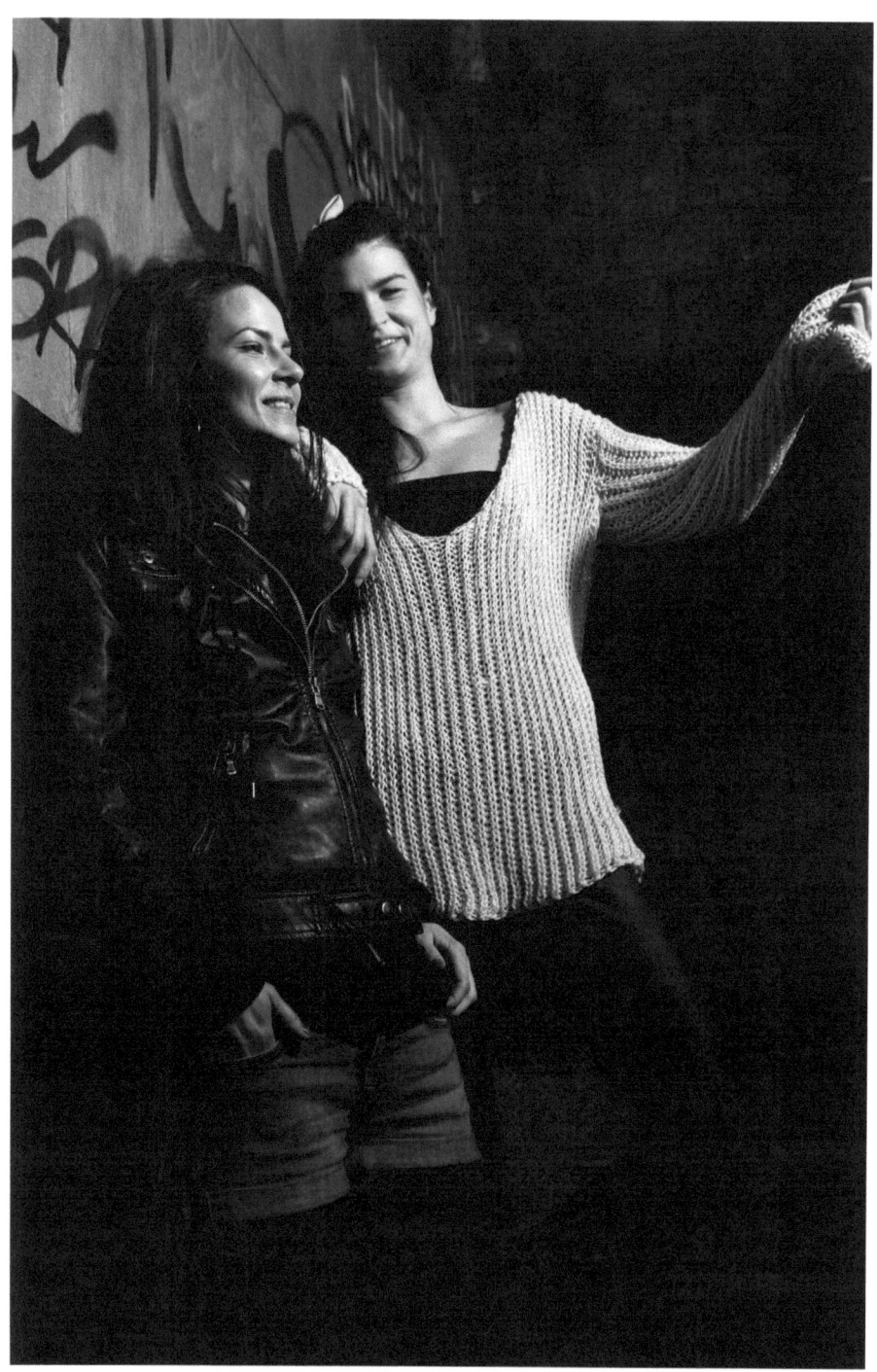

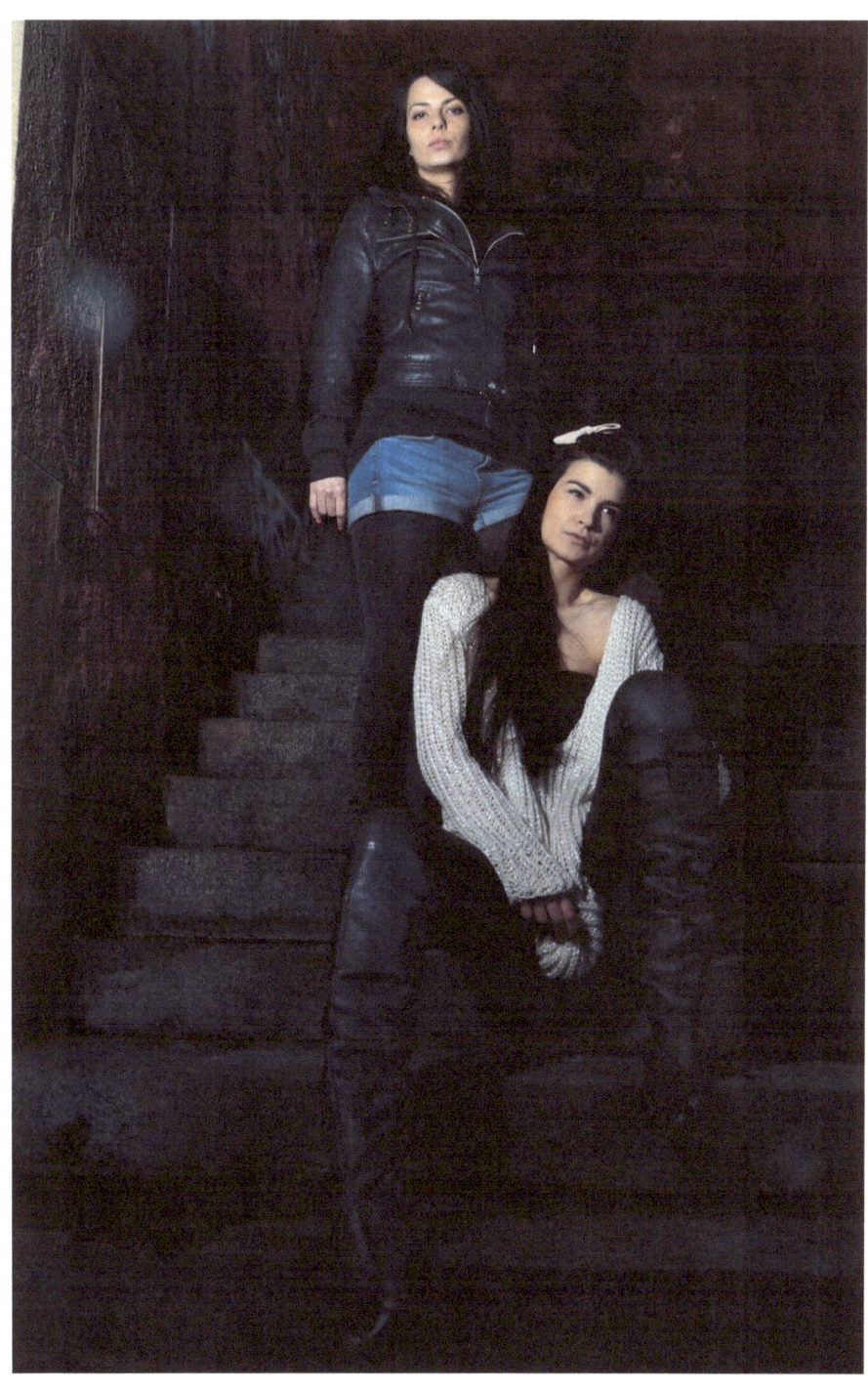

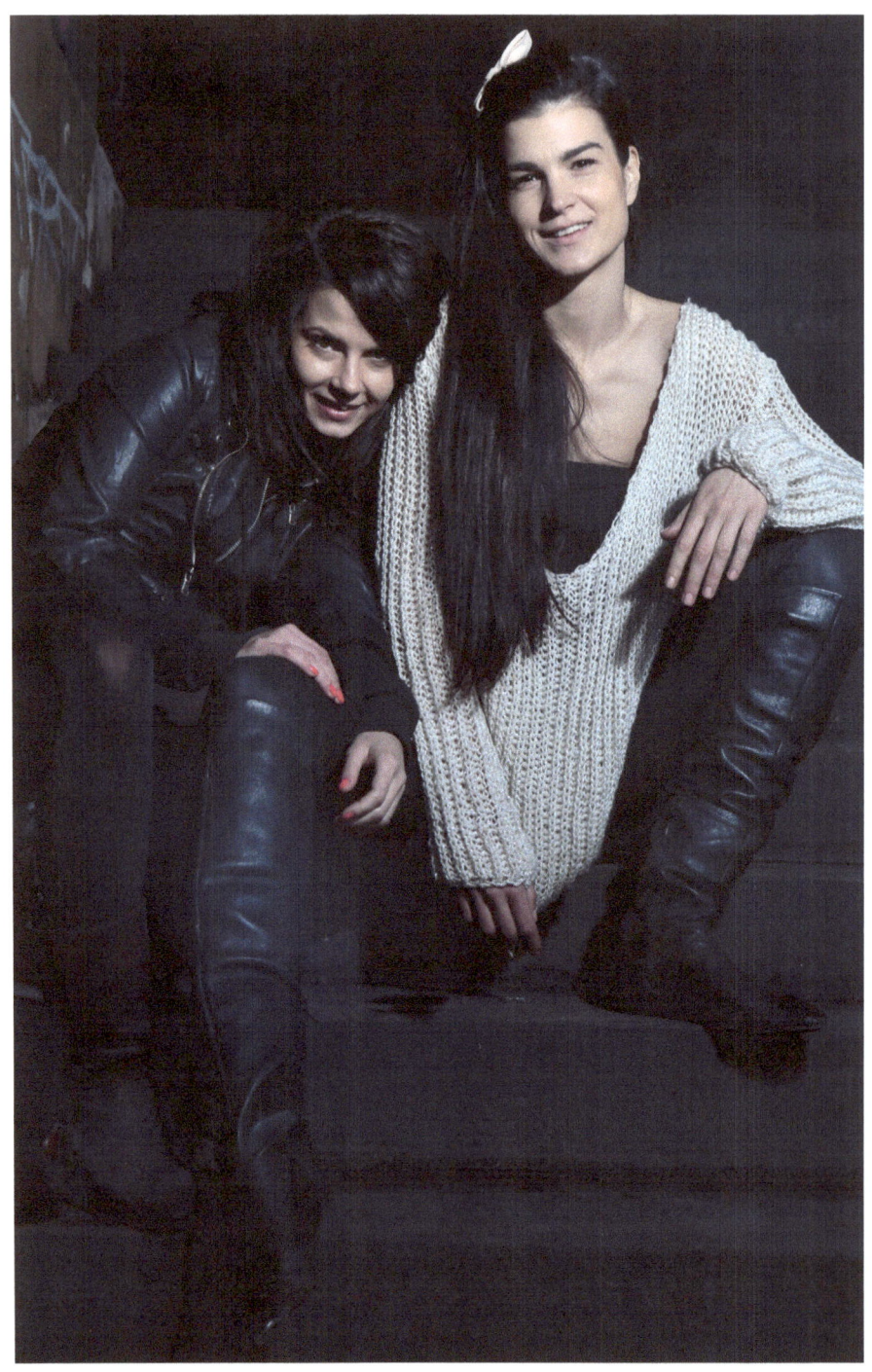

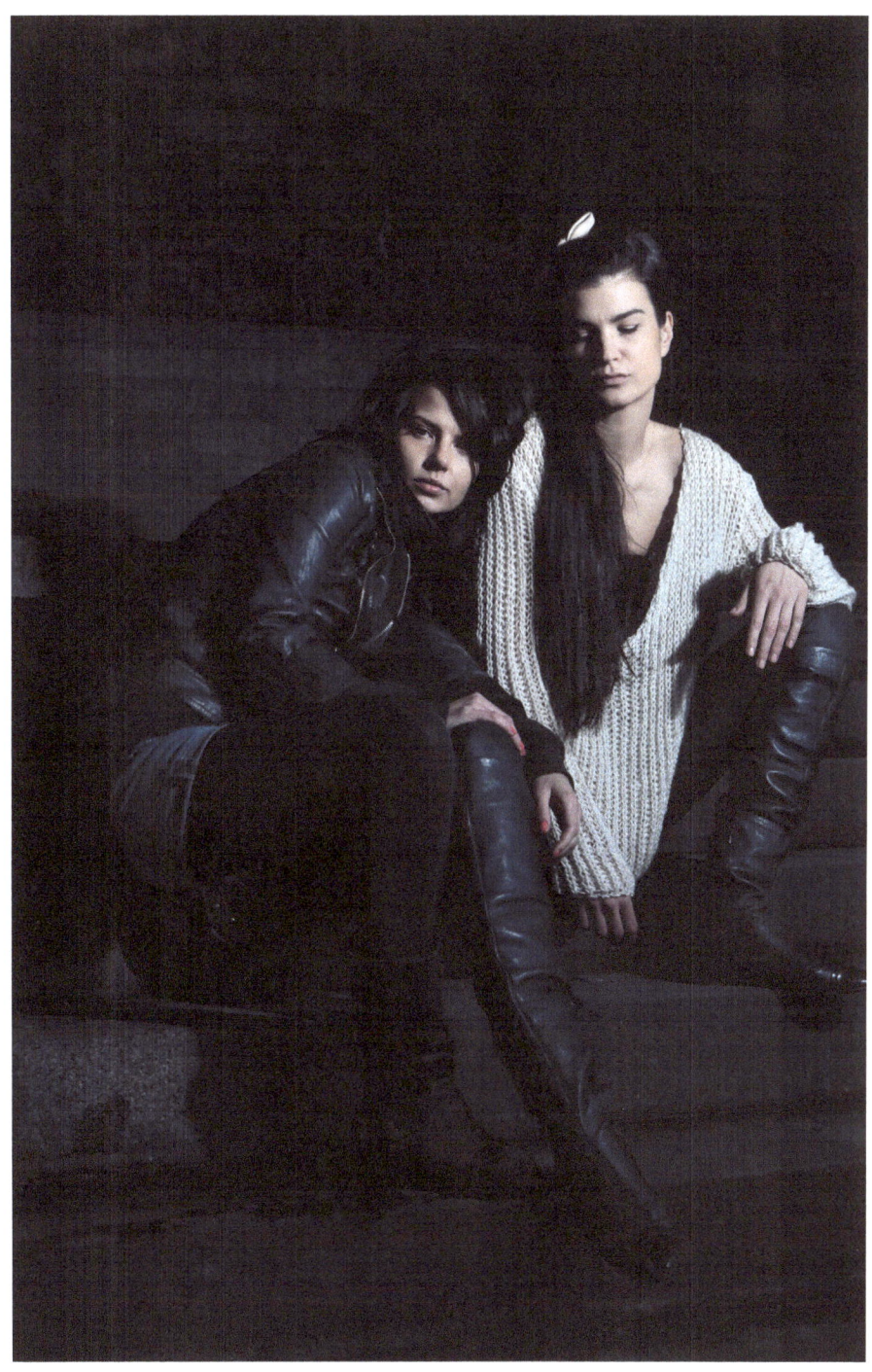

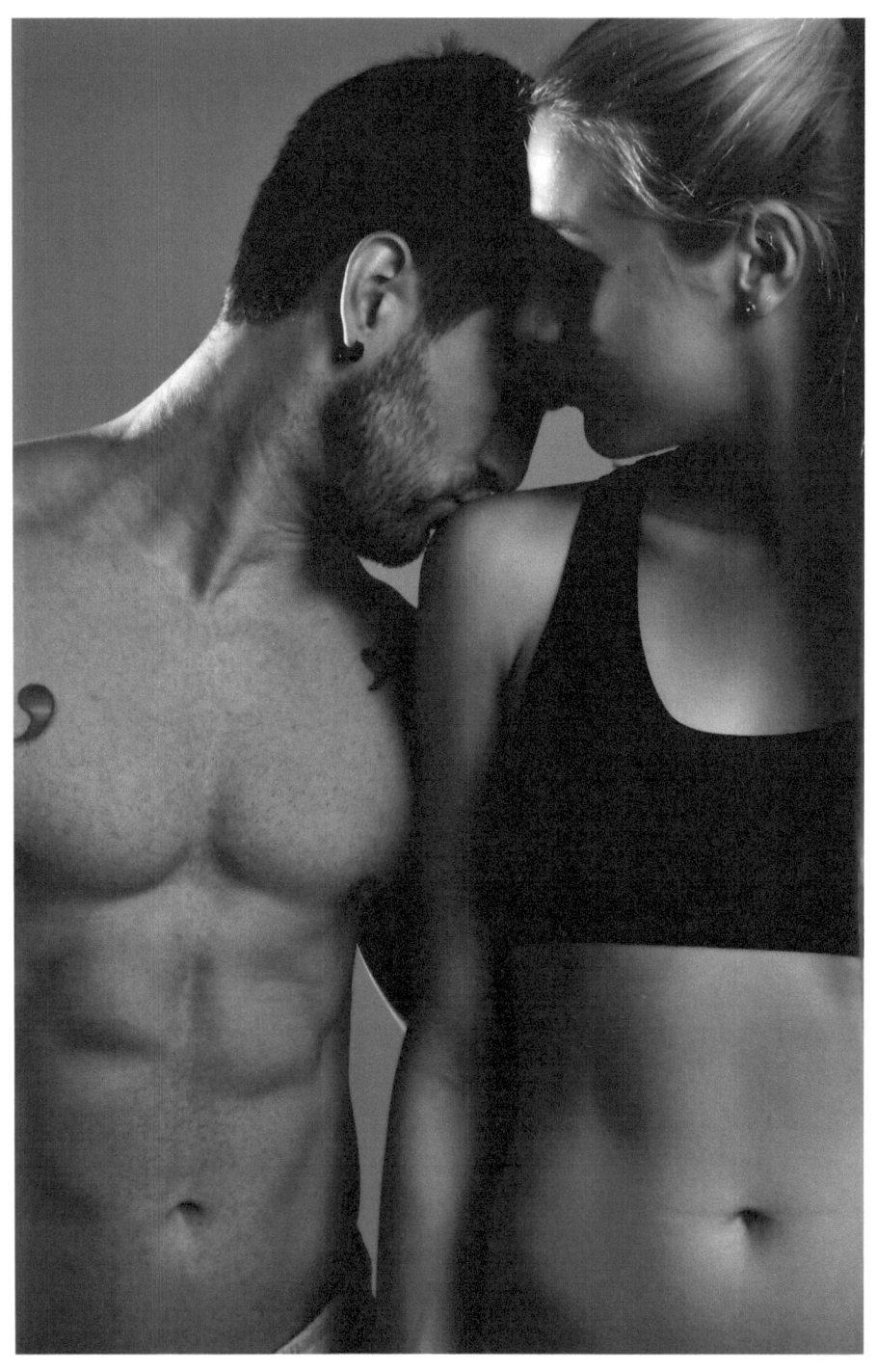

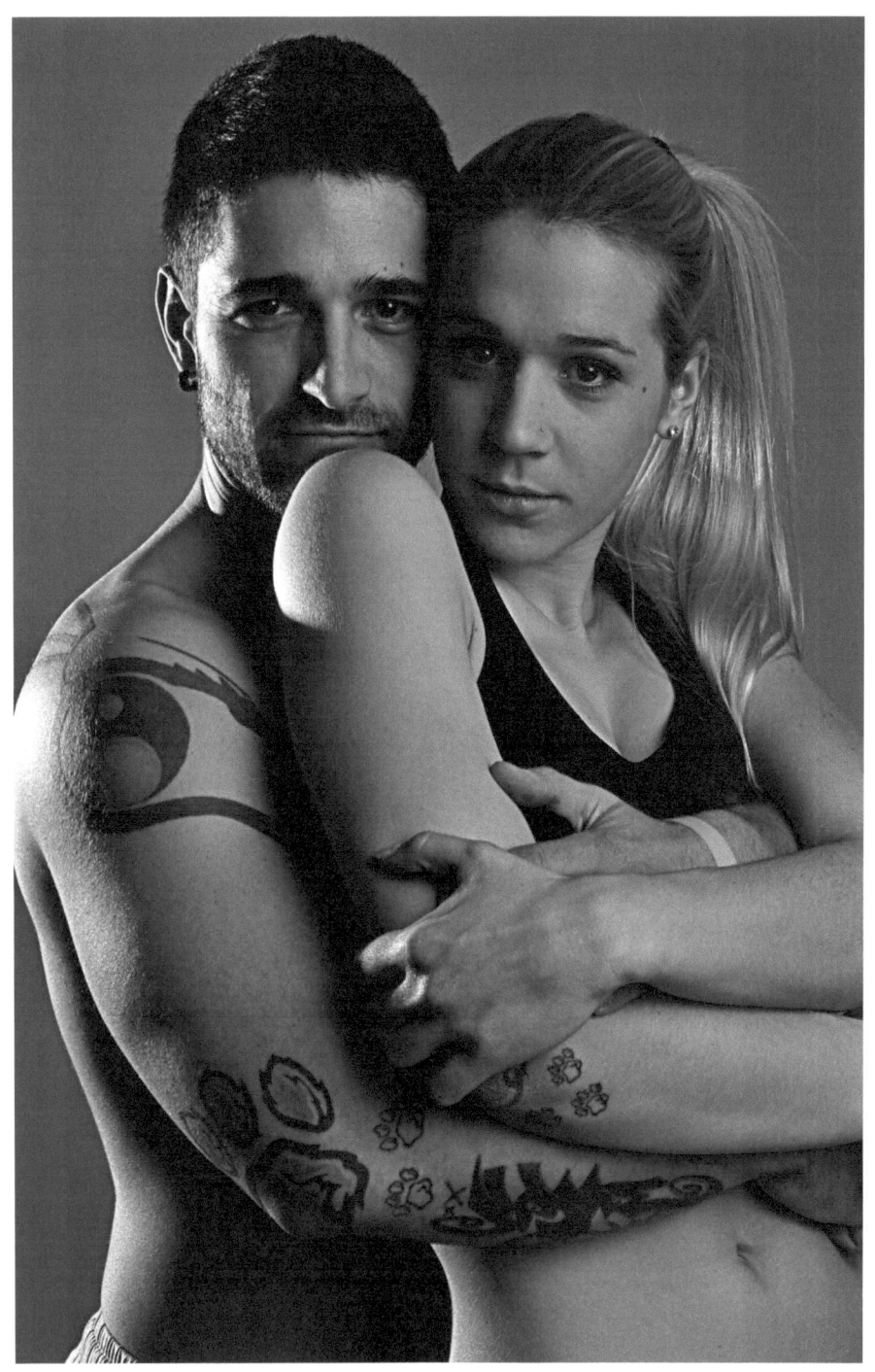

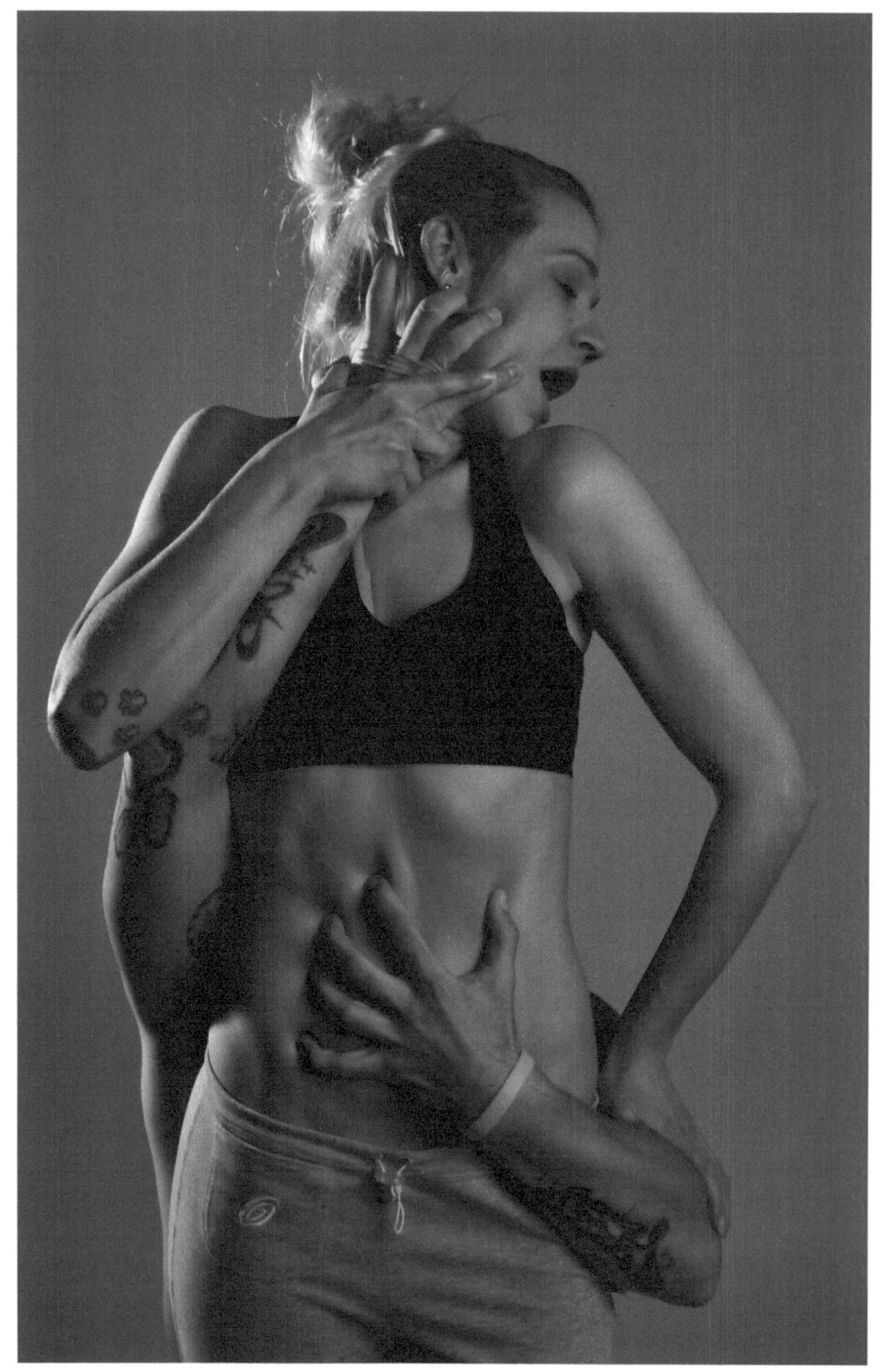

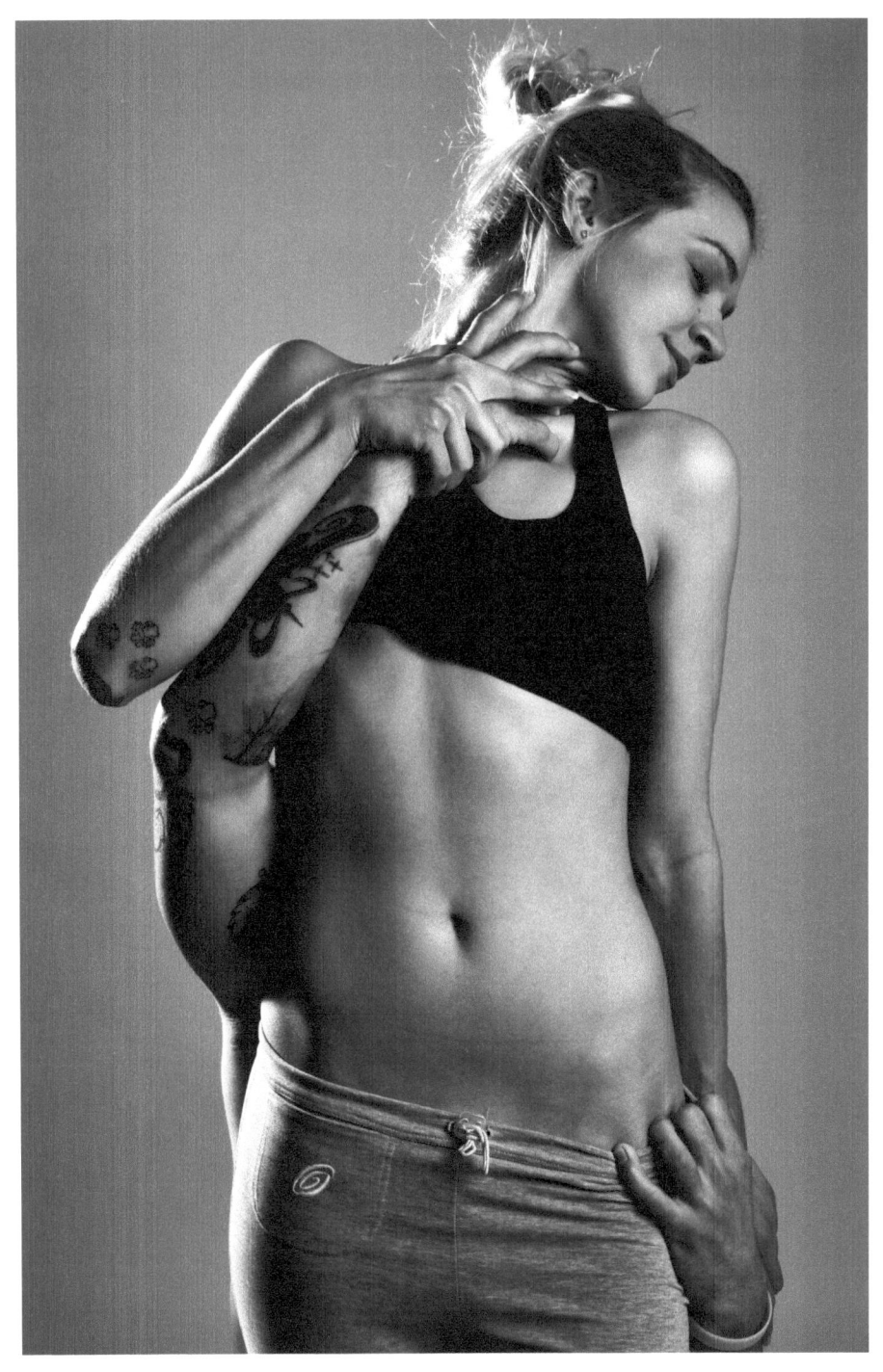

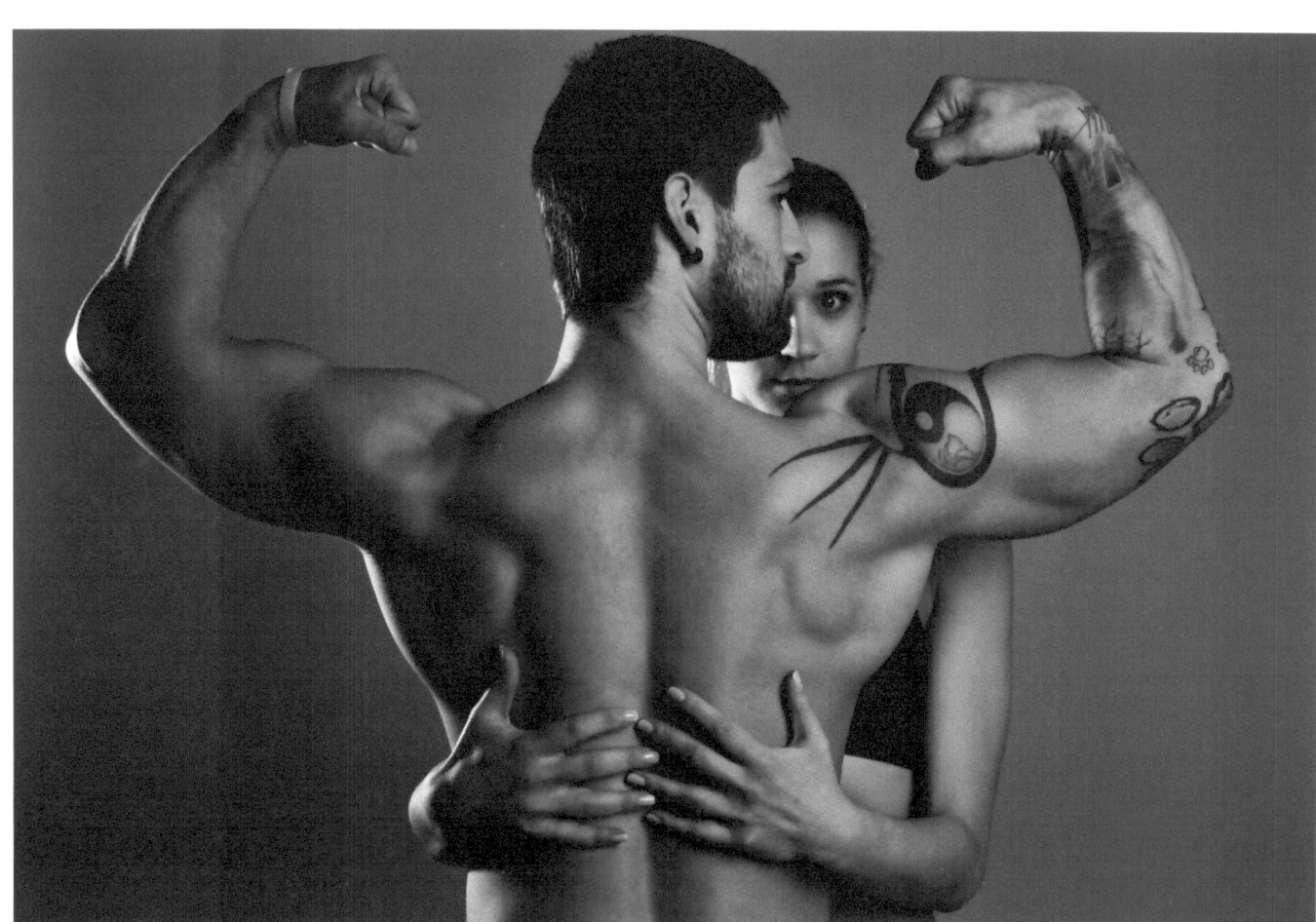

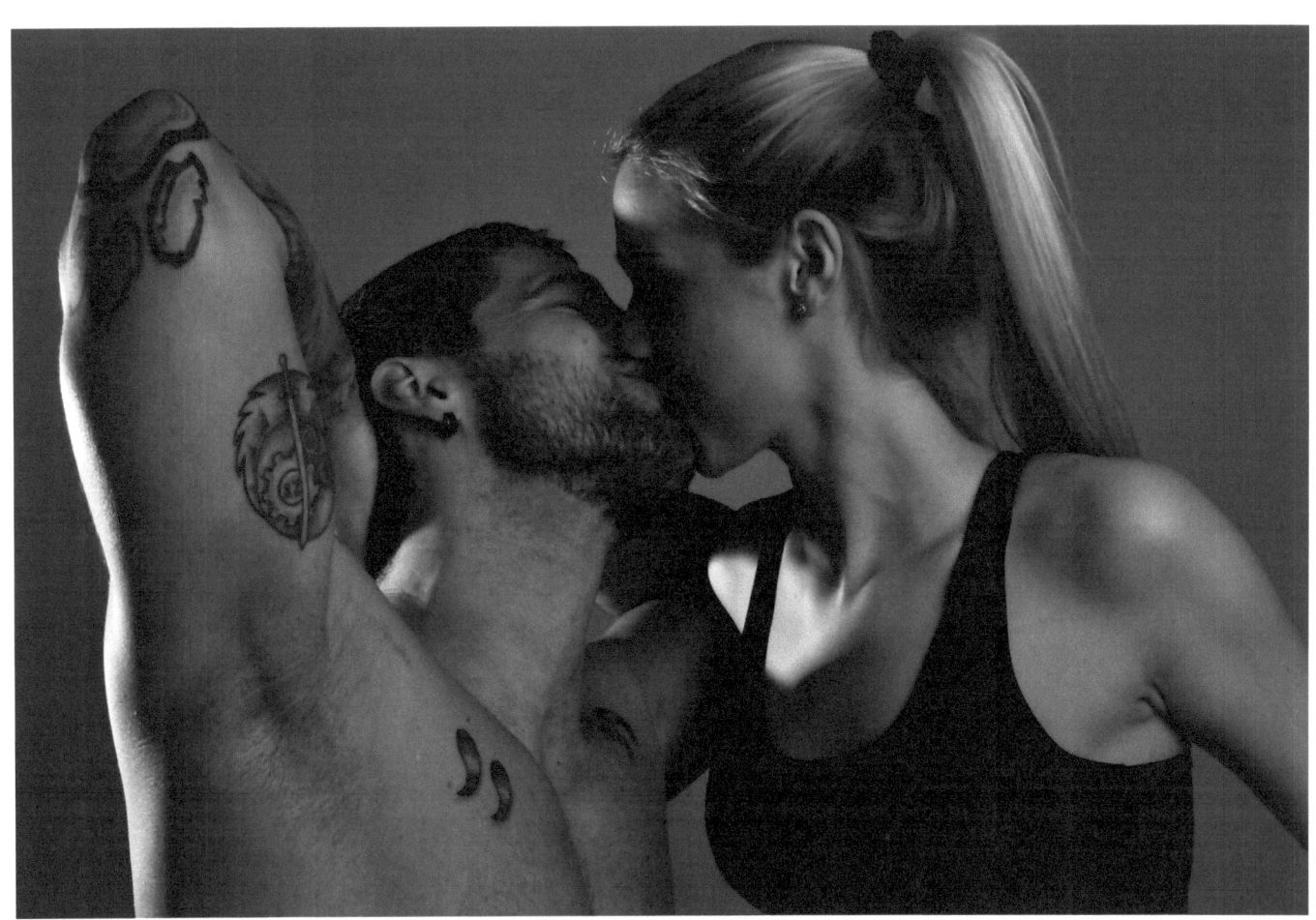

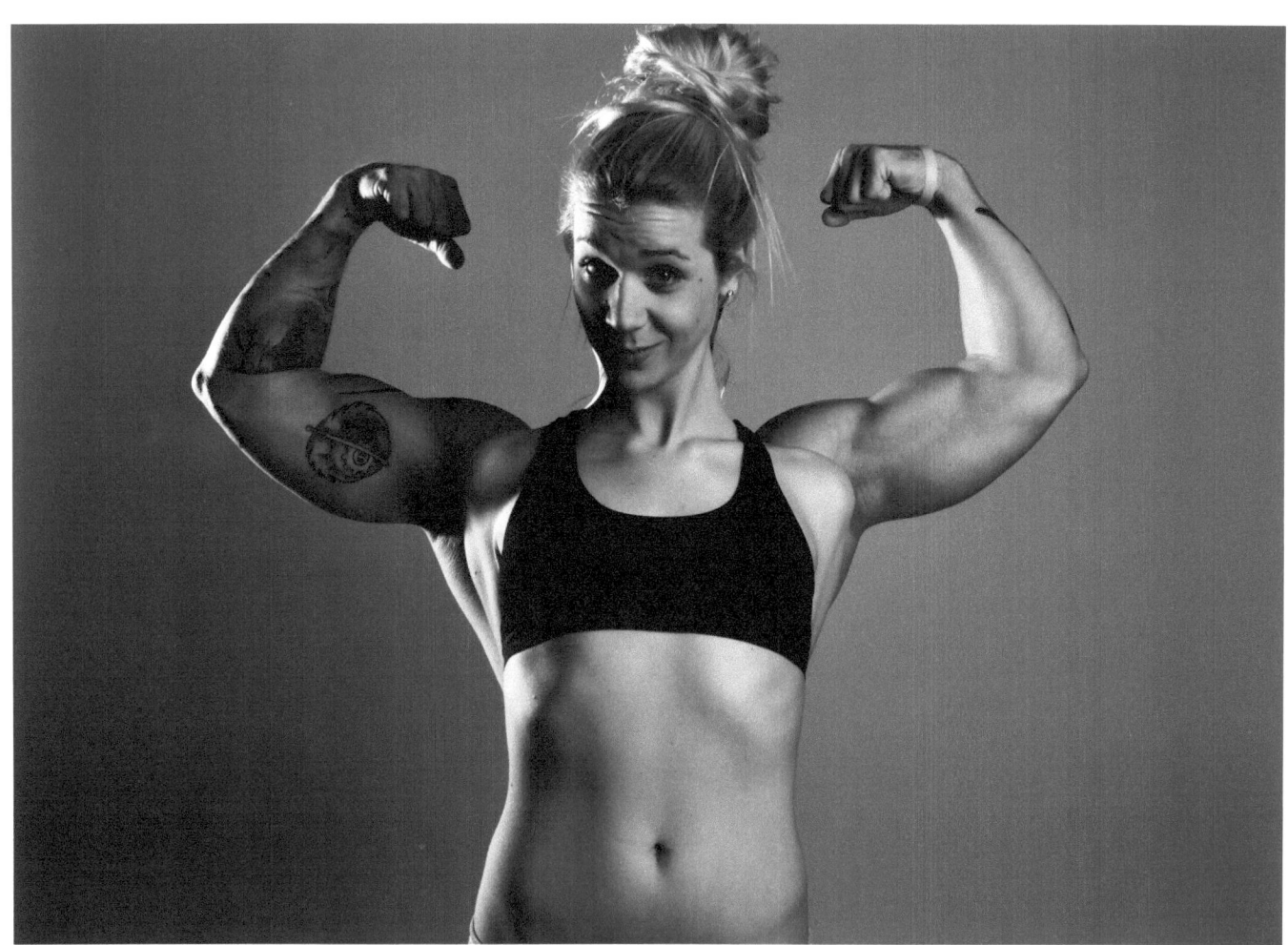

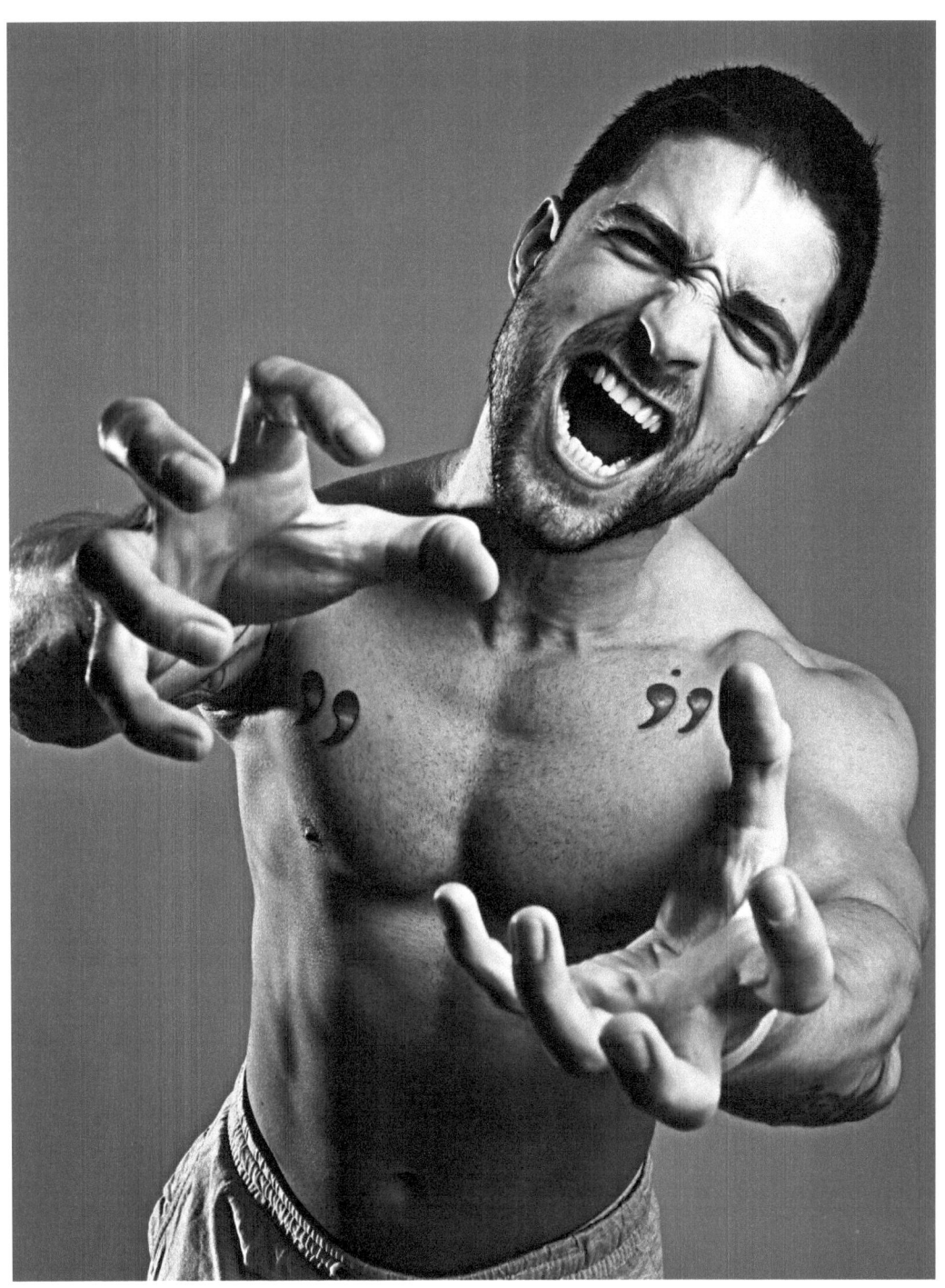

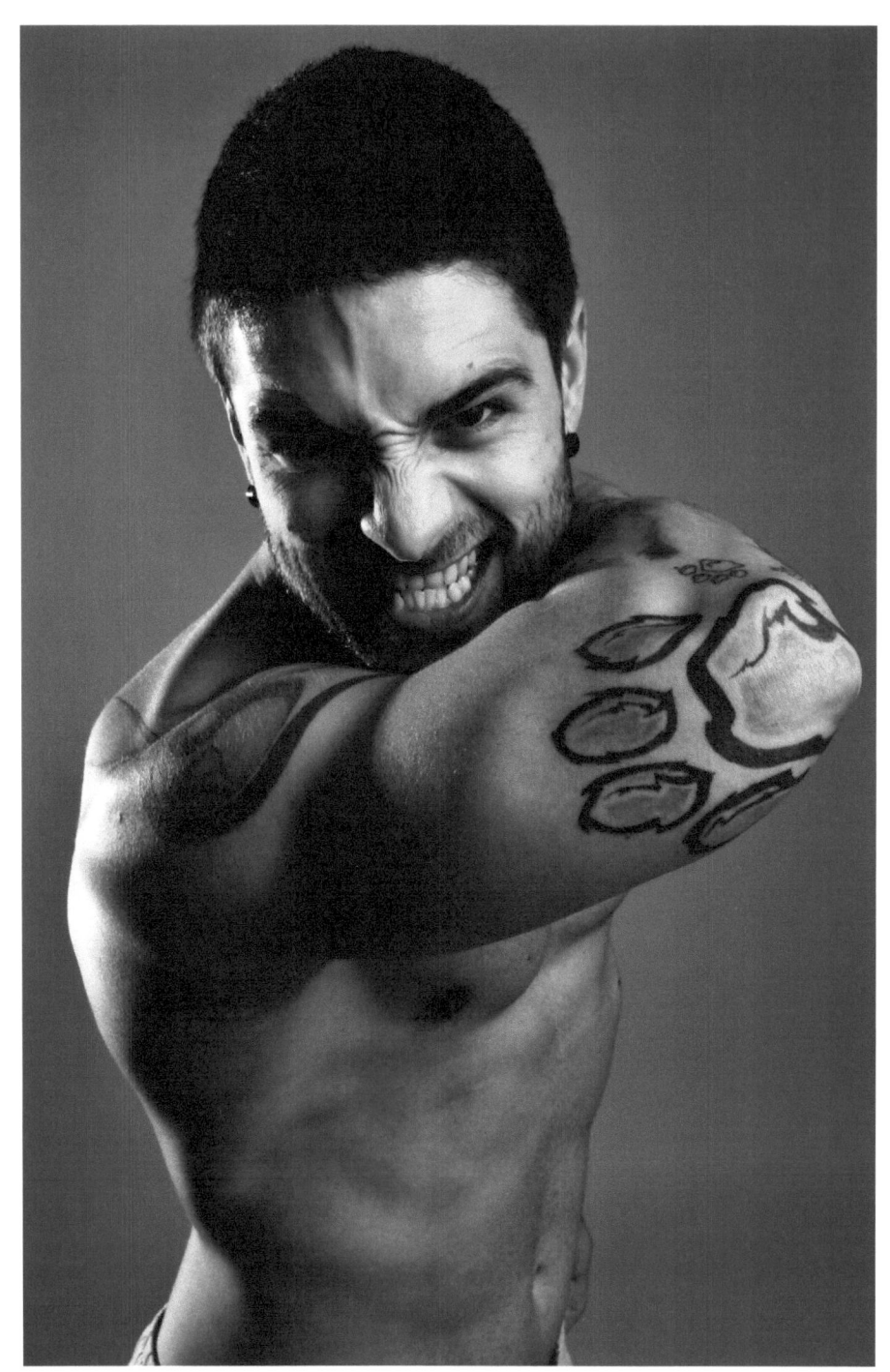

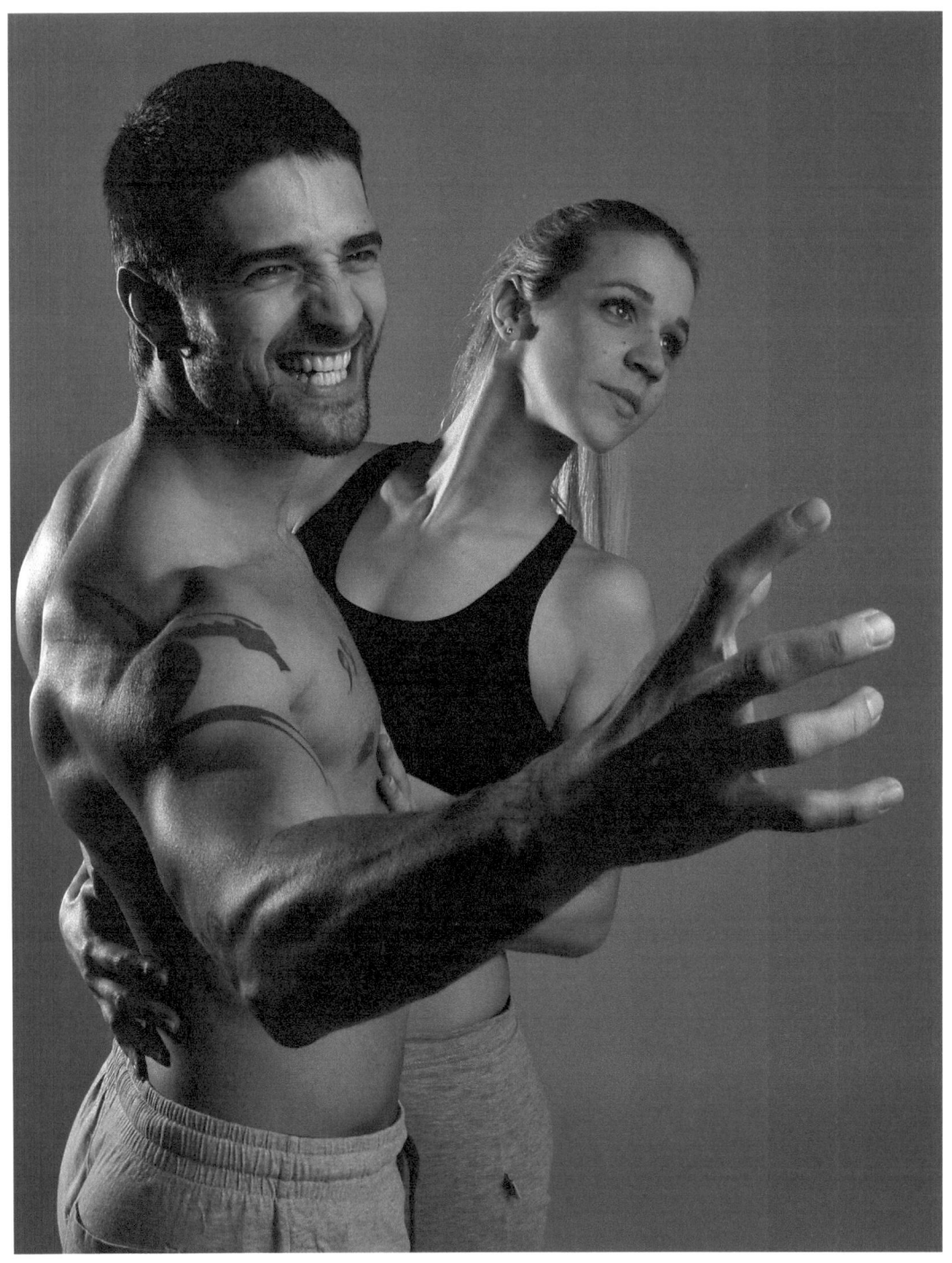

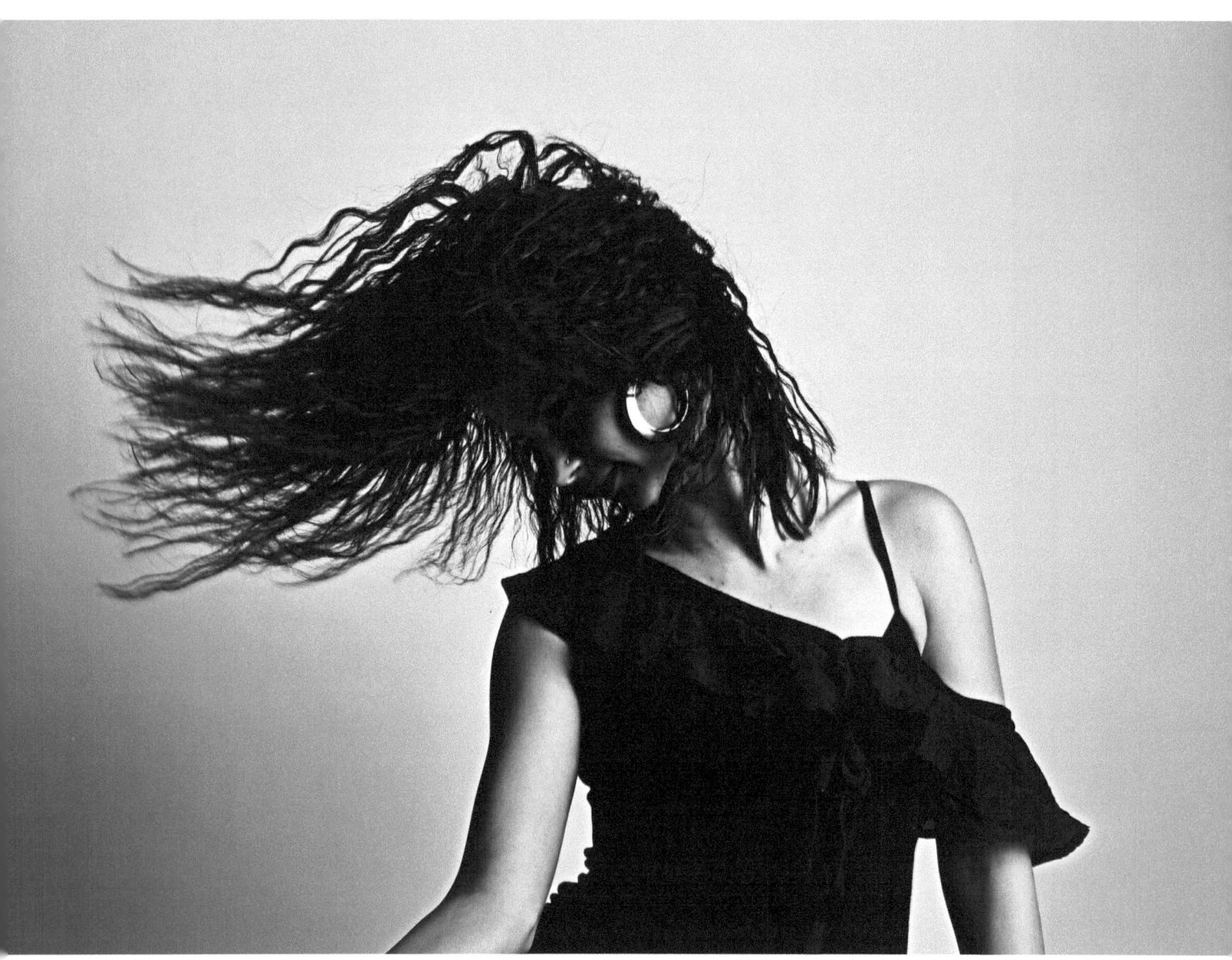

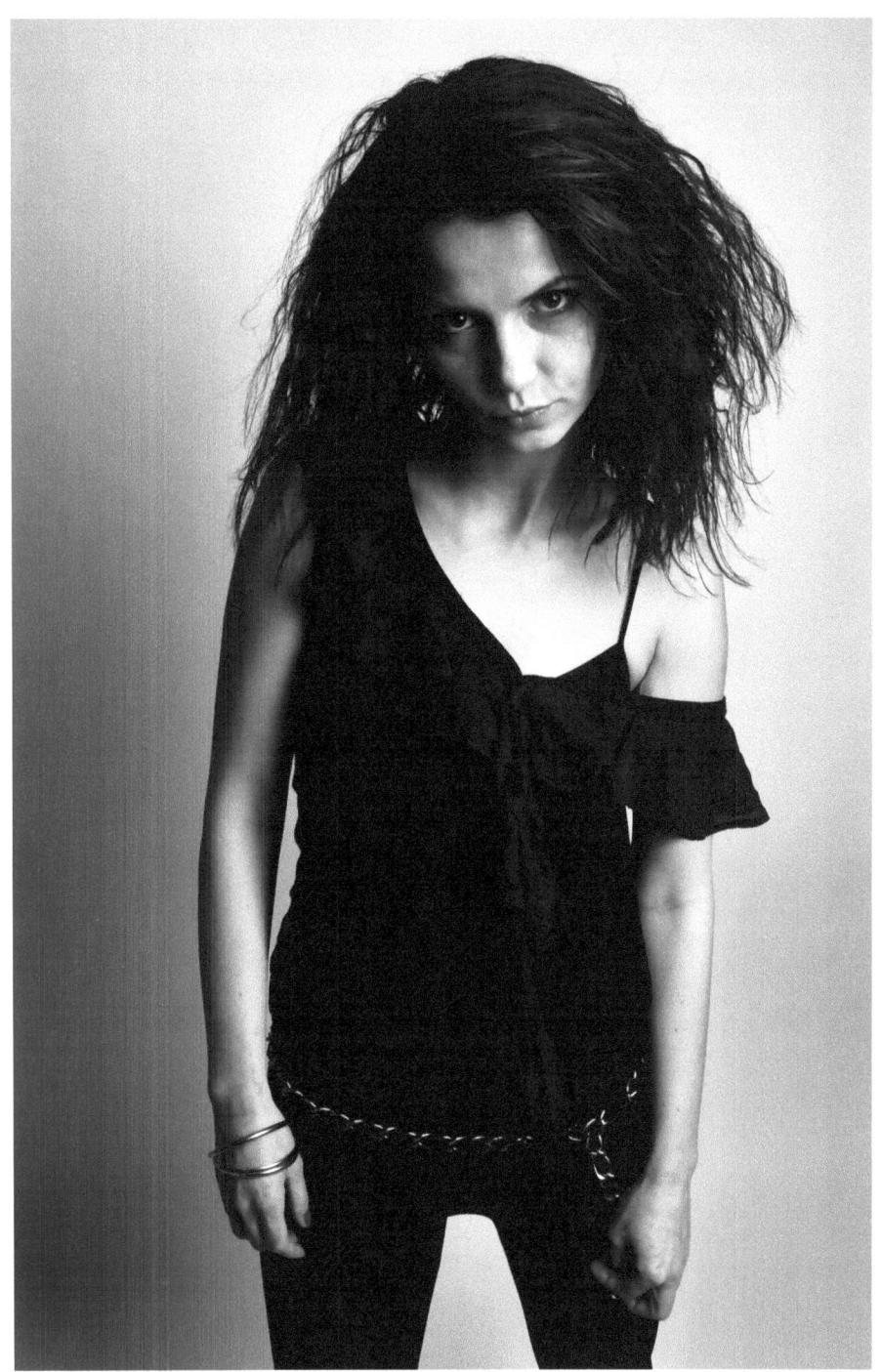

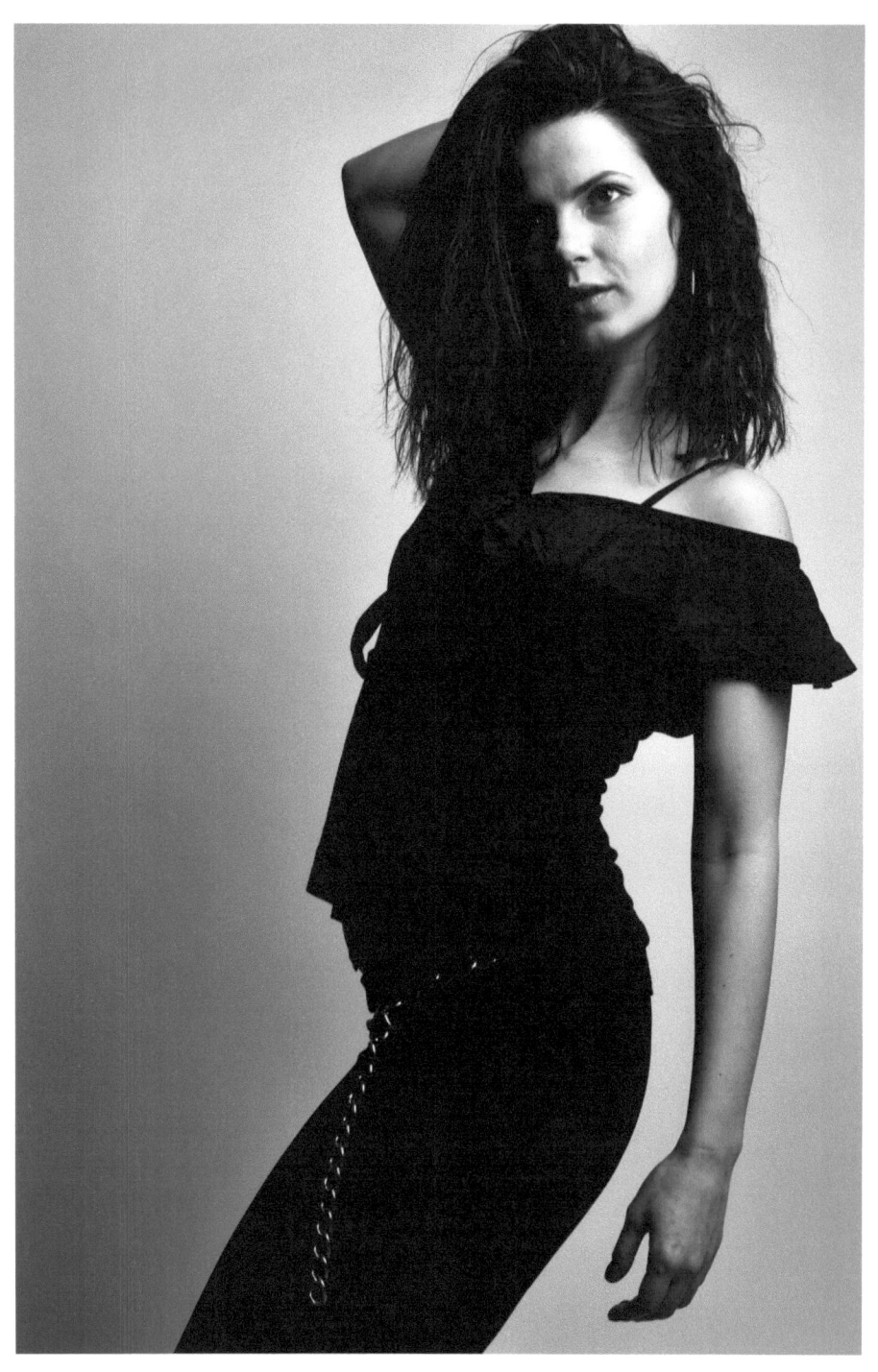

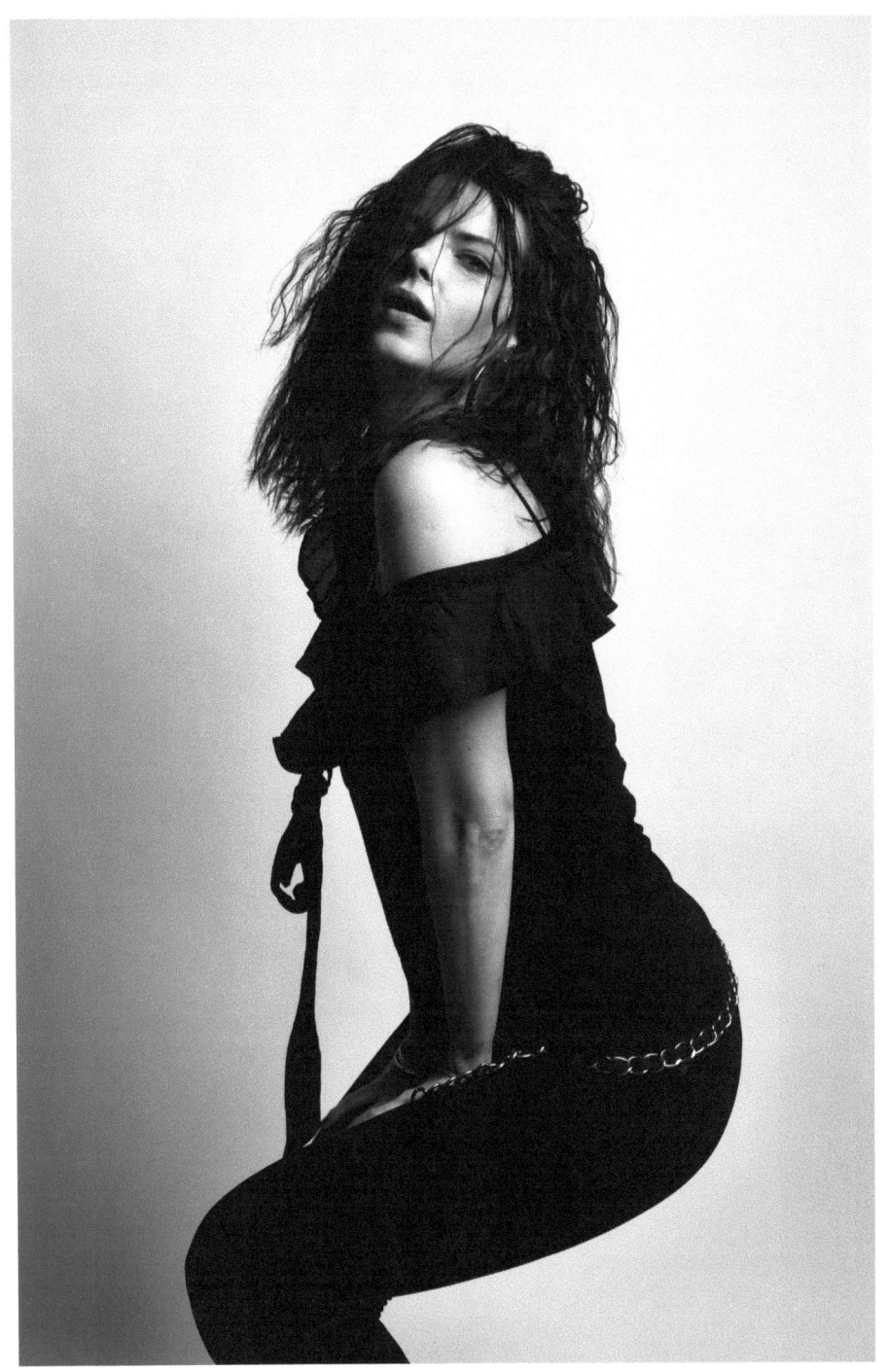

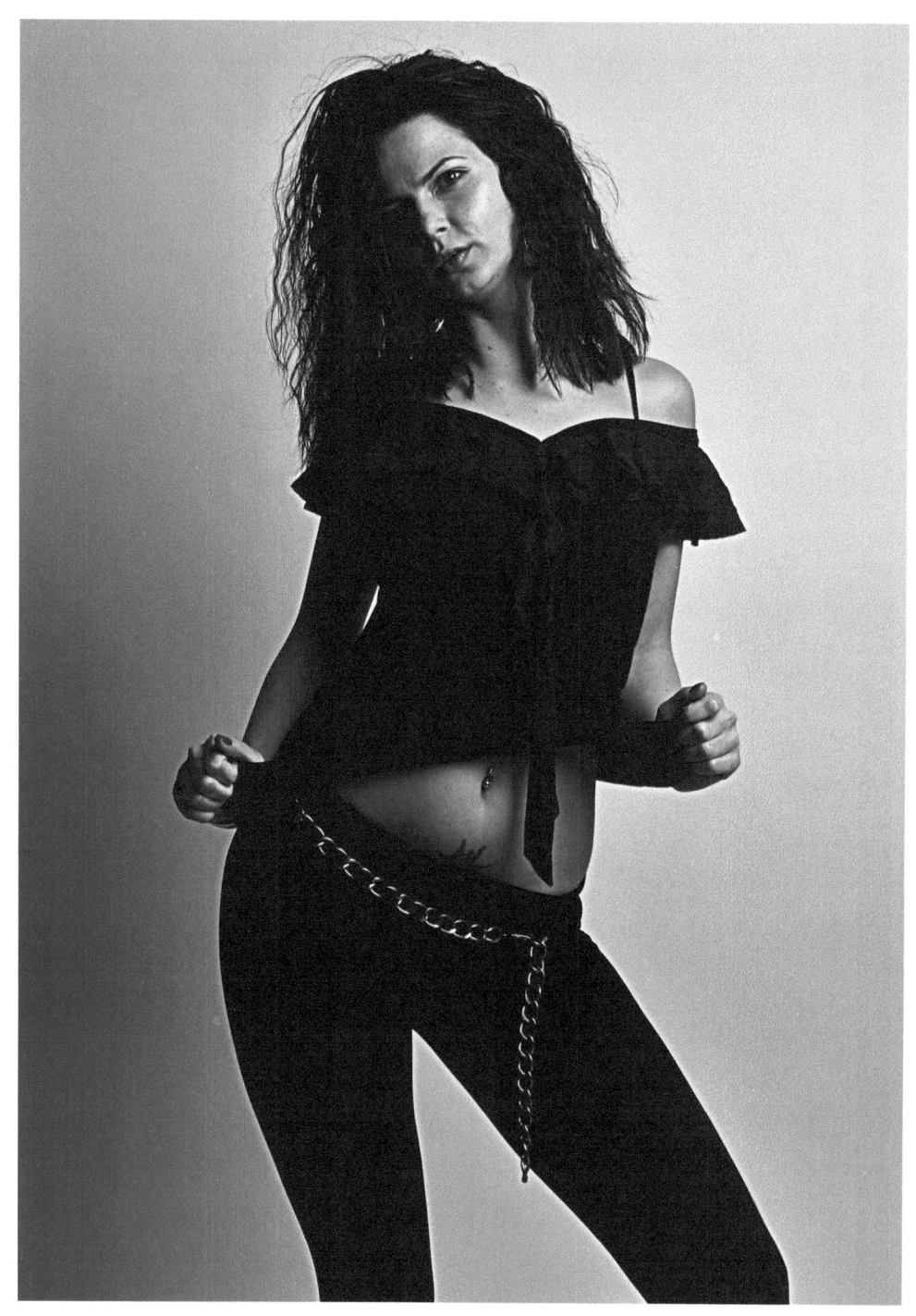

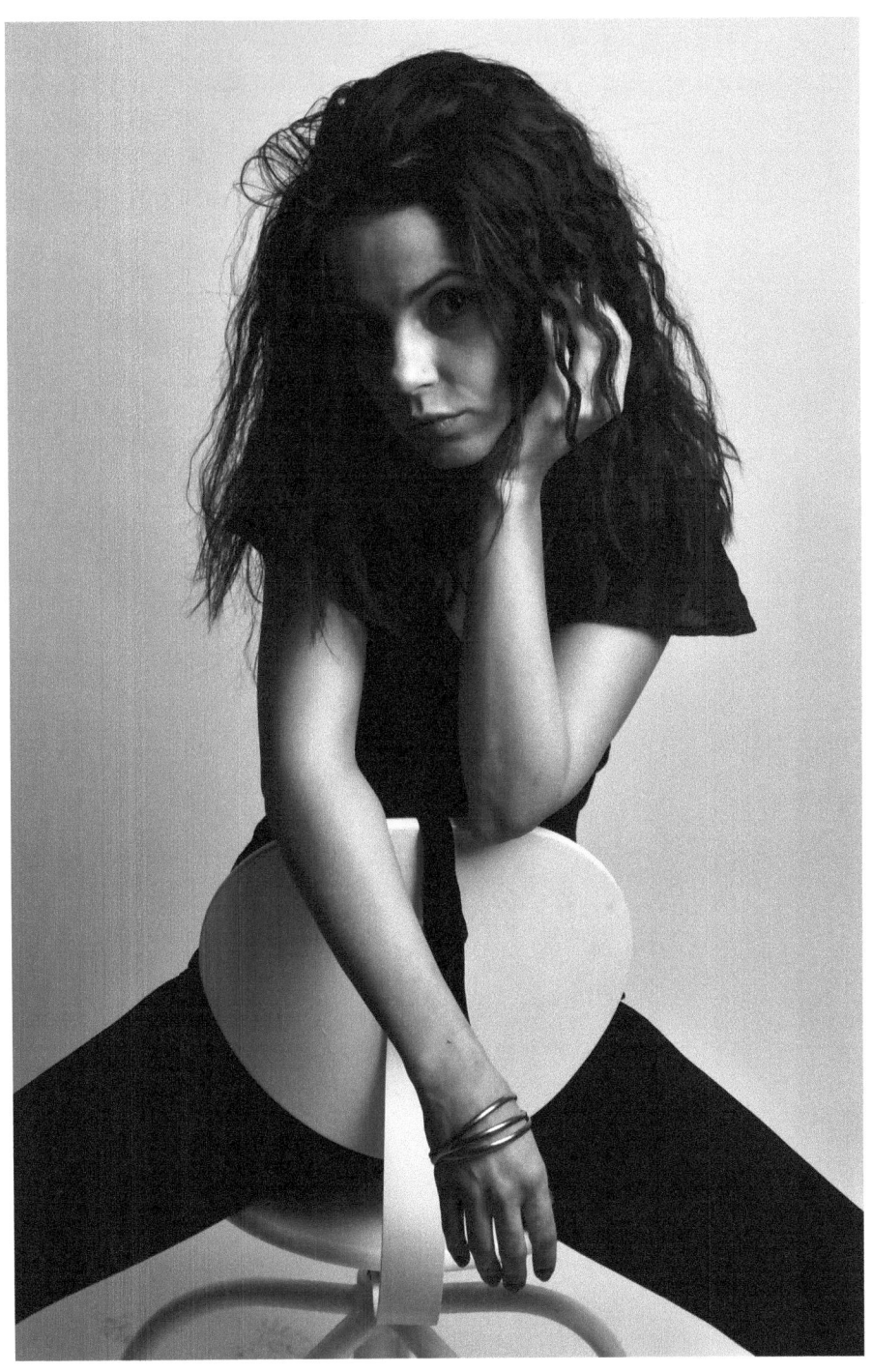

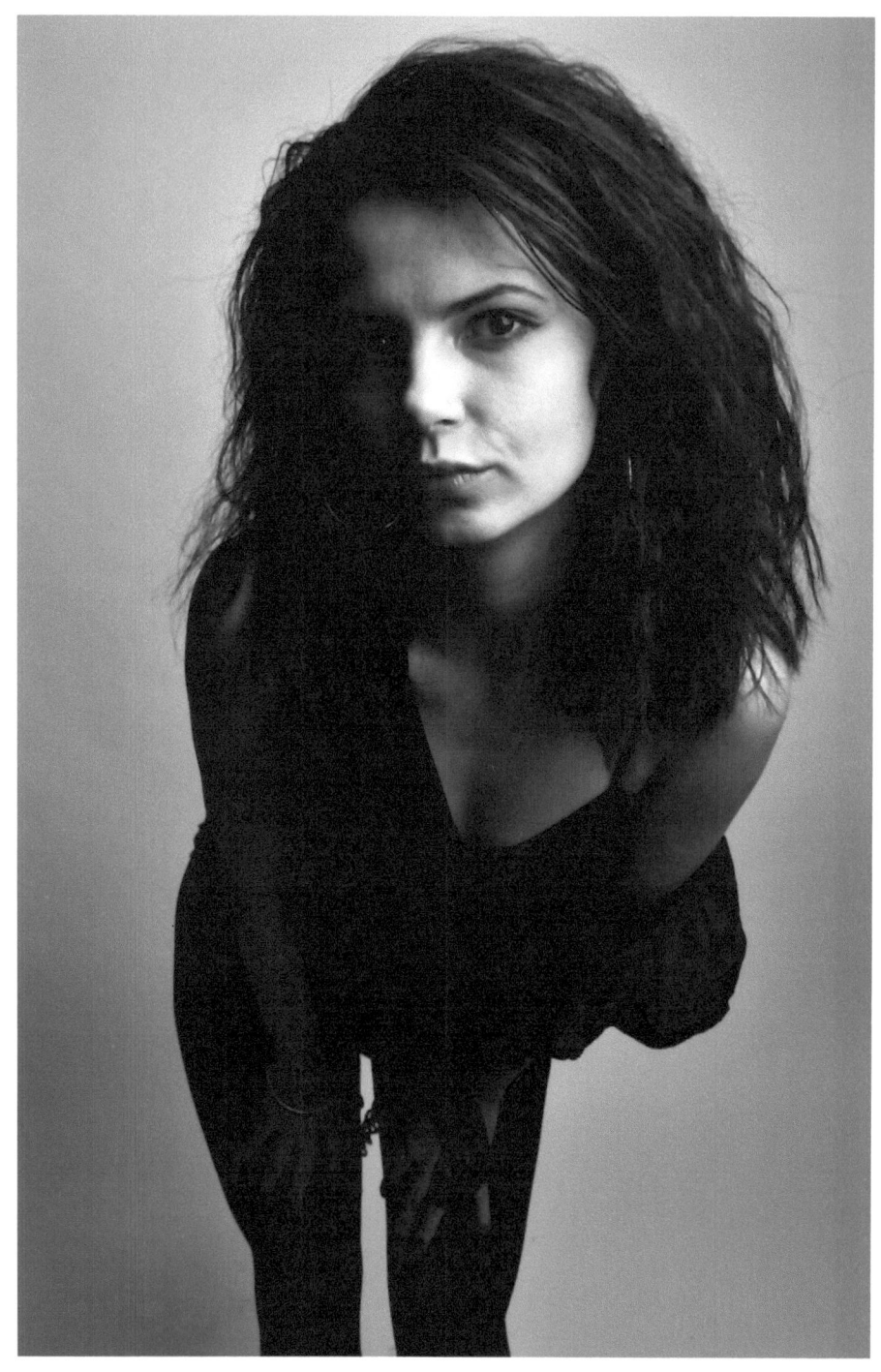

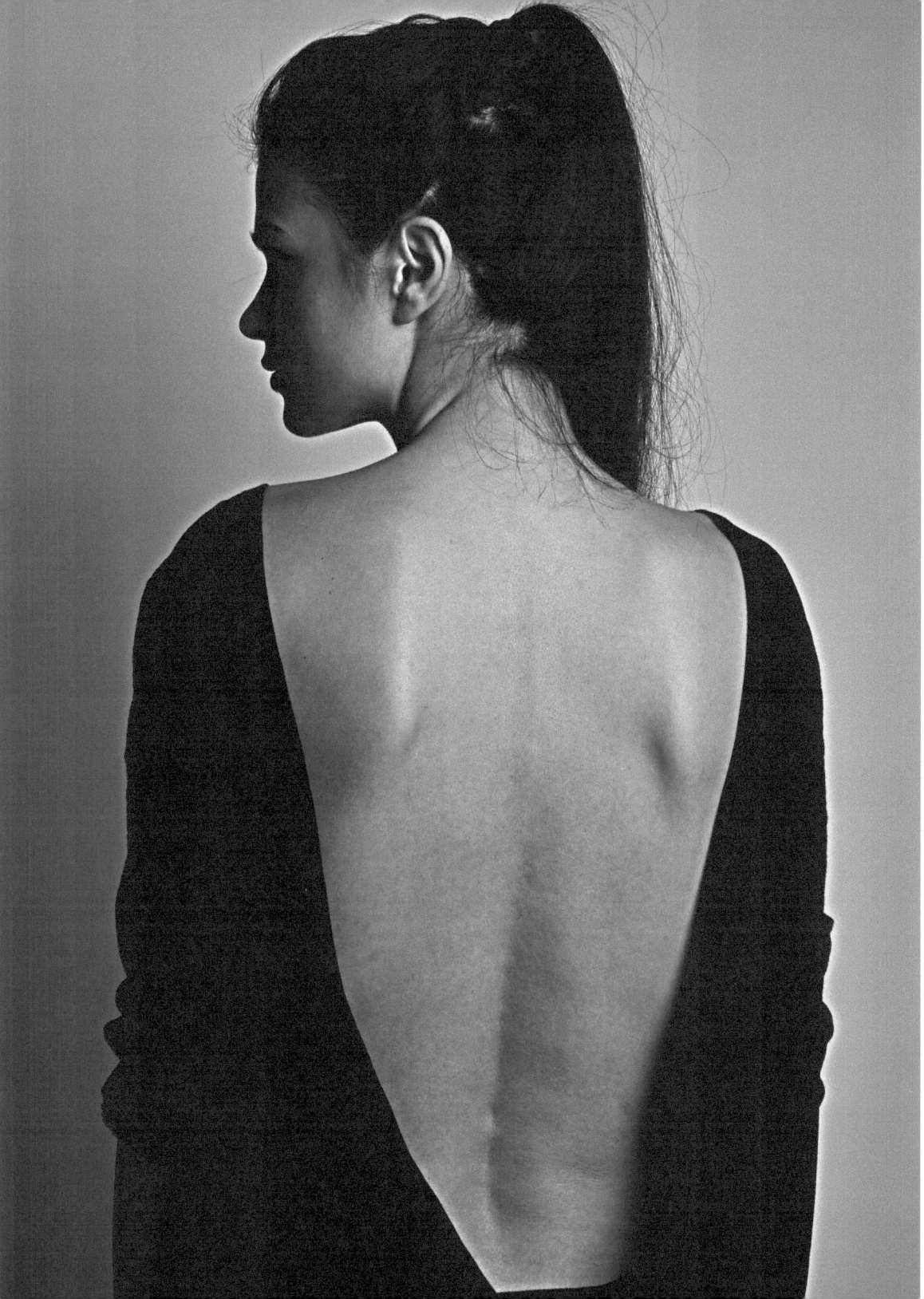

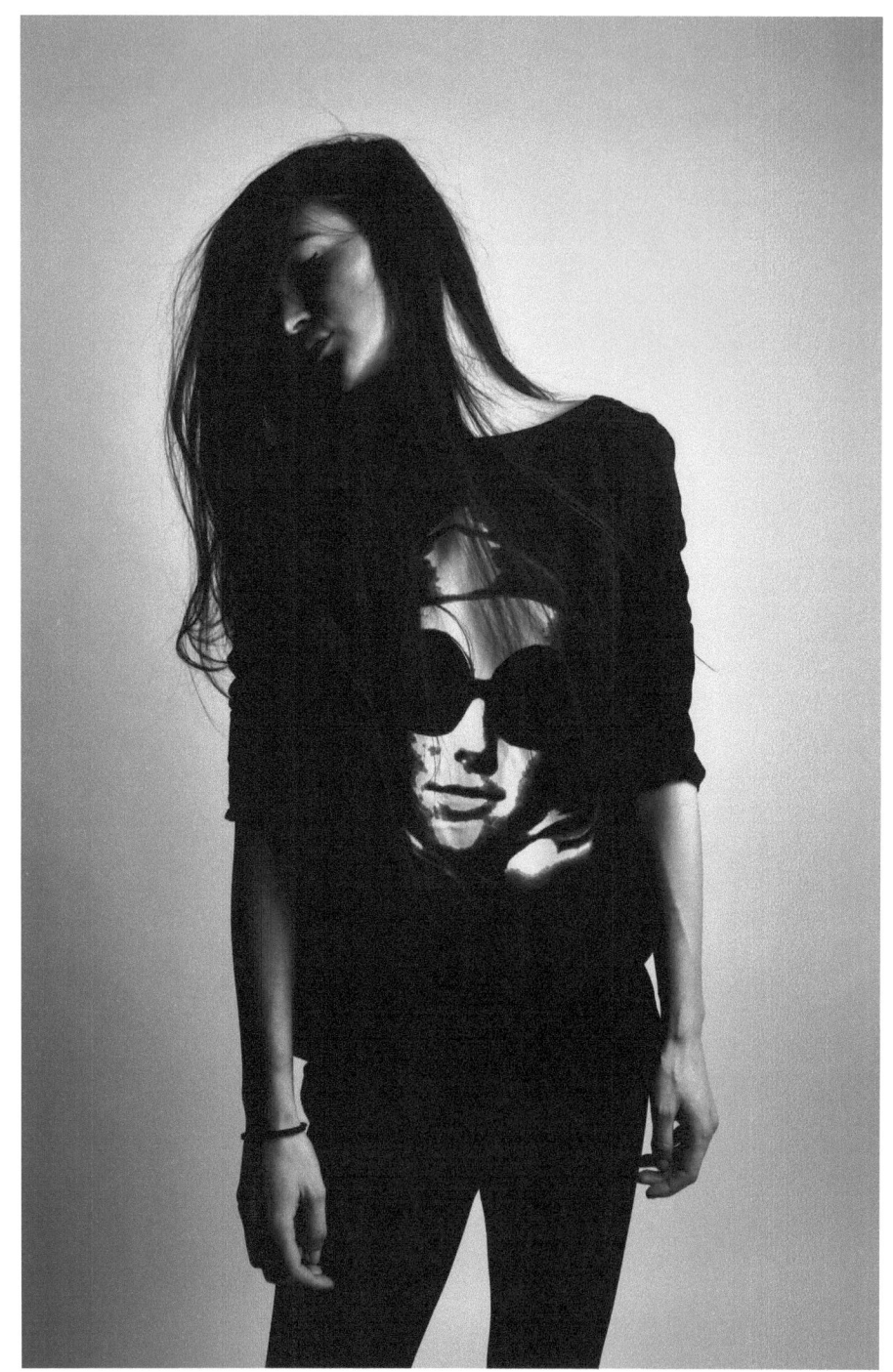

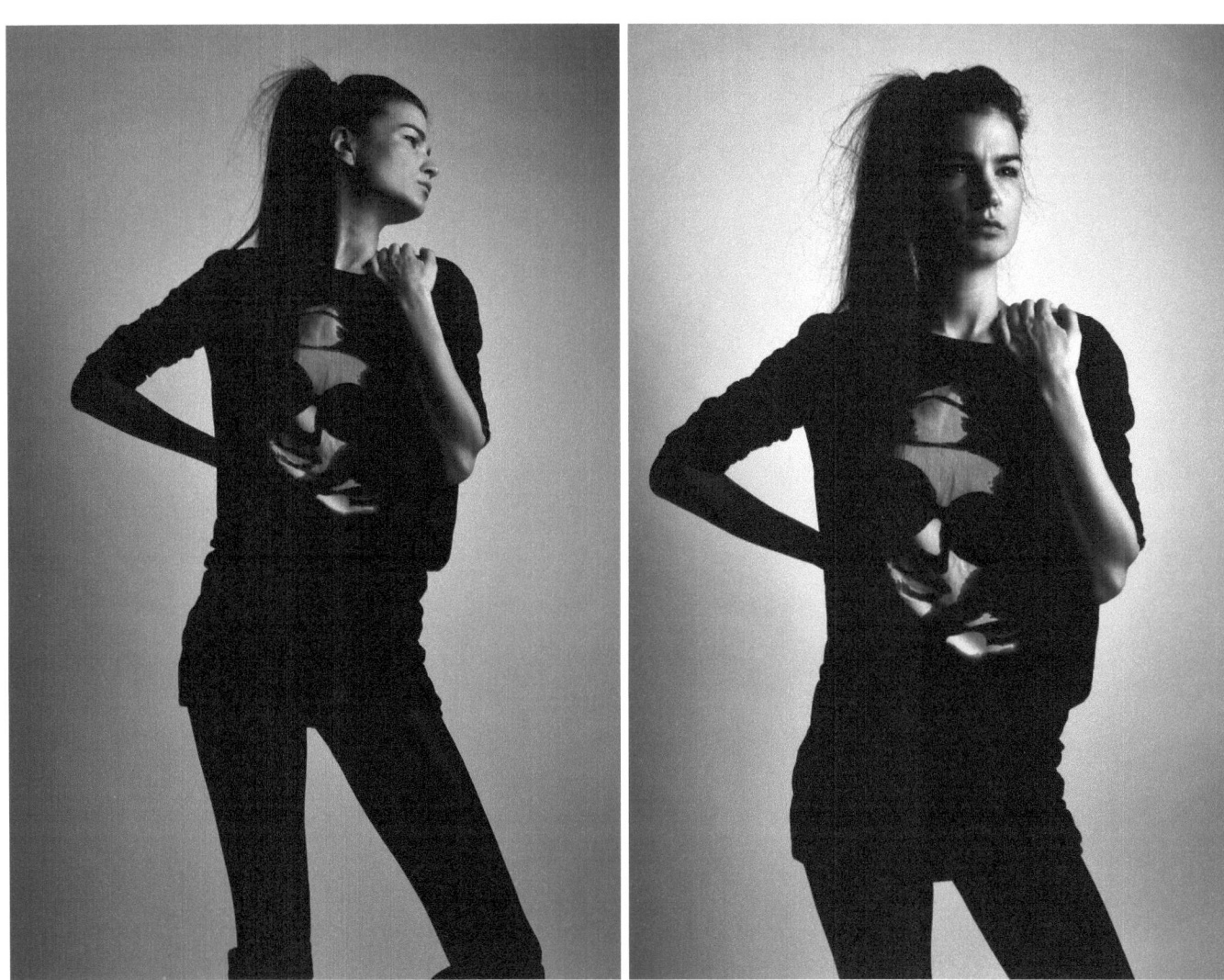

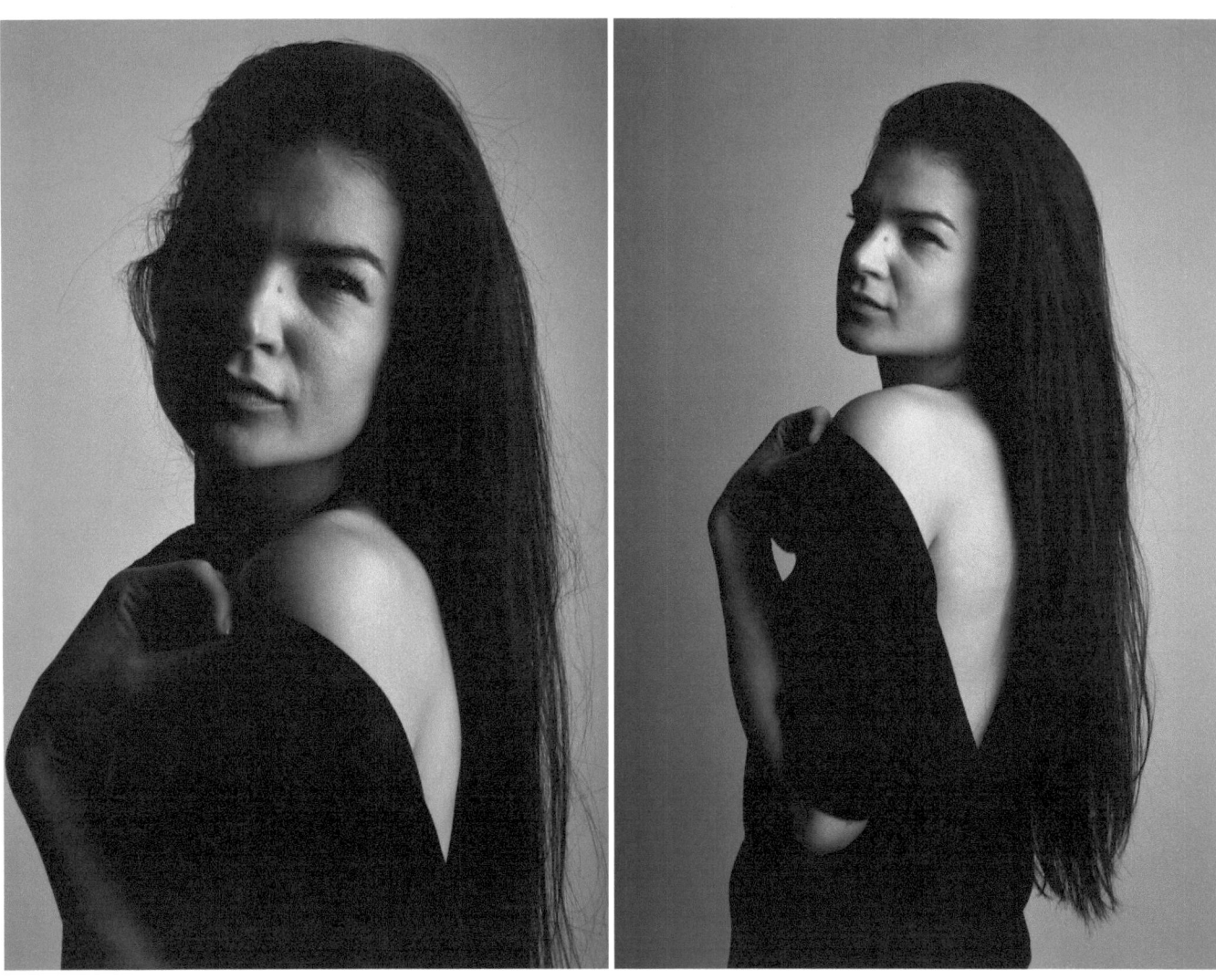

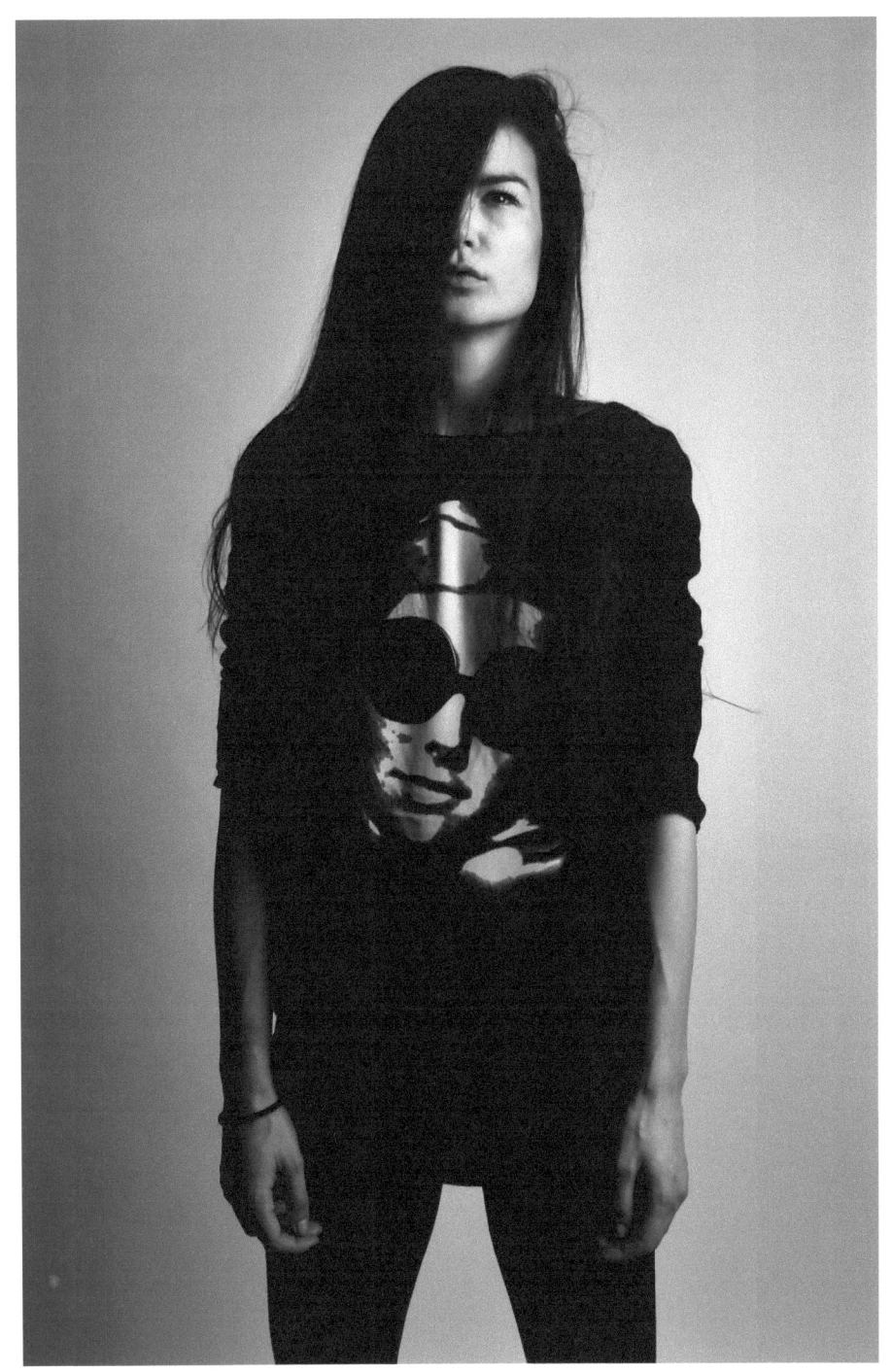

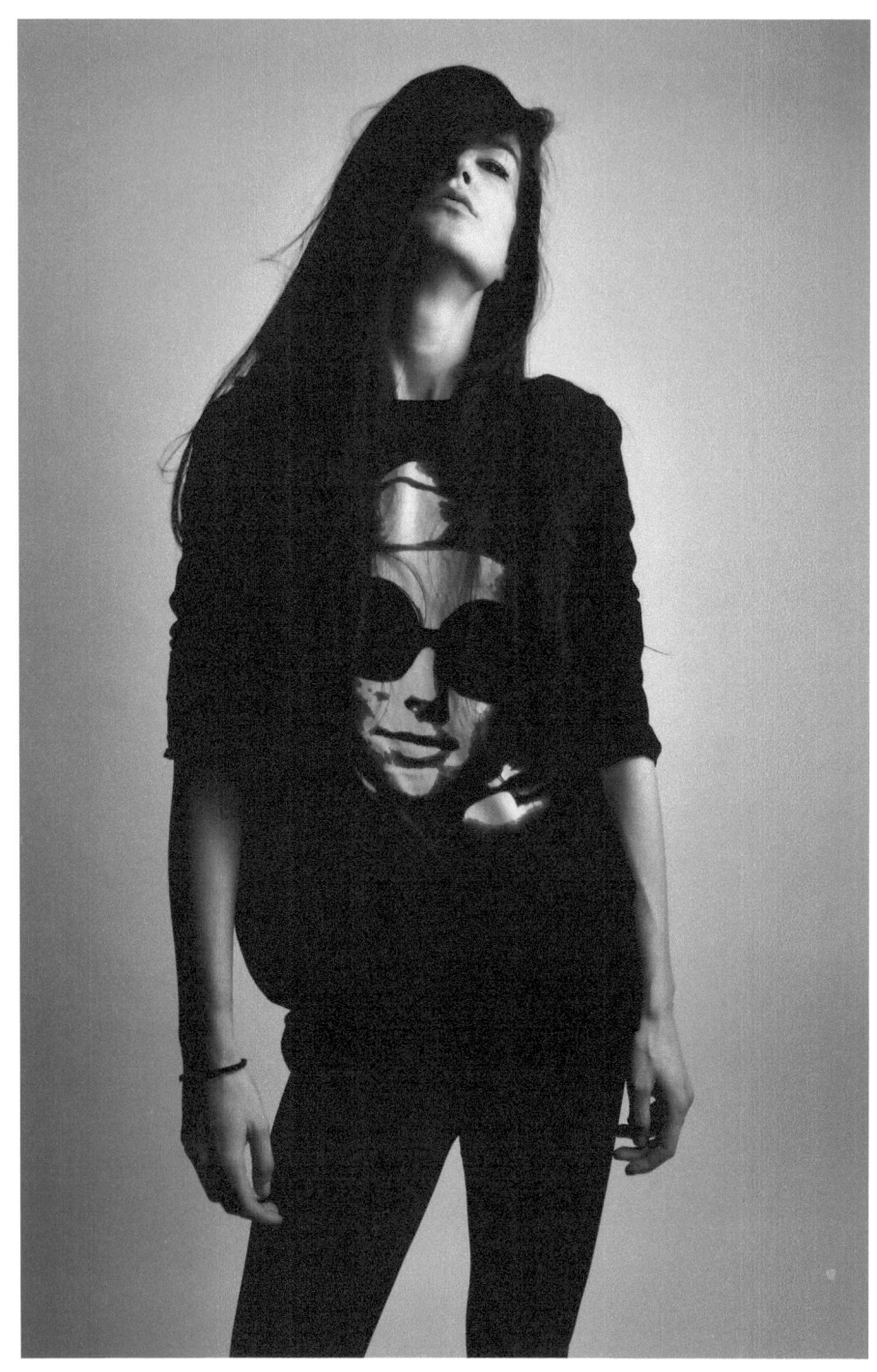

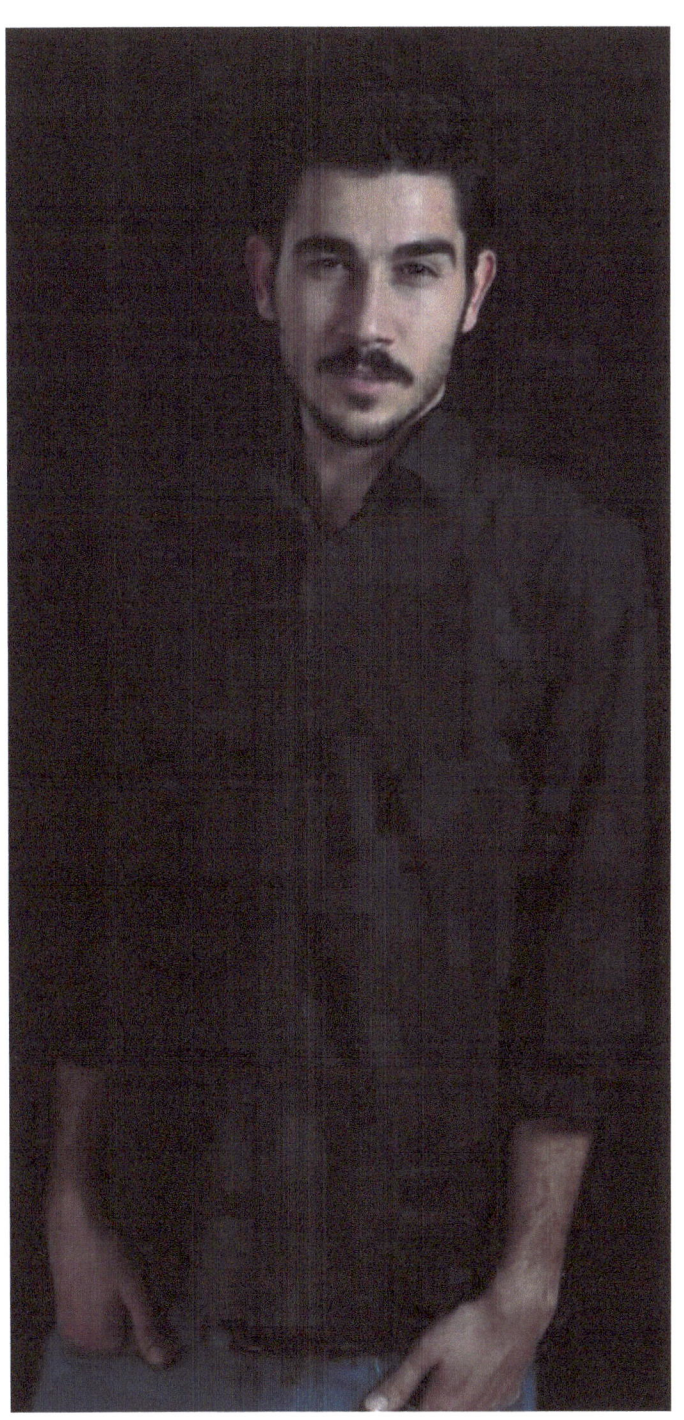

BEHIND THE LENS

I was born in Adana, Turkey on November 4th, 1984

I graduated on Tourist Guidance at Kocaeli University . I began working as a Tour Guide, I moved to İstanbul., where I still live. My job was field that gave me a sense of seeing the world around in a different perspective, or was my country, full of natural and ancestral beauties. And I met lots of photographers I saw beautiful shots. In that time, the camera they were holding looked to me spaceship. Later on, I wanted to grab one of the them .

Today unlike other fields, Photography requires better and newer styles all the time. It updates itself, and it is not cliché, that's why I am in love with it.

www.ingramcontent.com/pod-product-compliance
Lightning Source LLC
Chambersburg PA
CBHW050855180526
45159CB00007B/2685